Croney on Watercolor

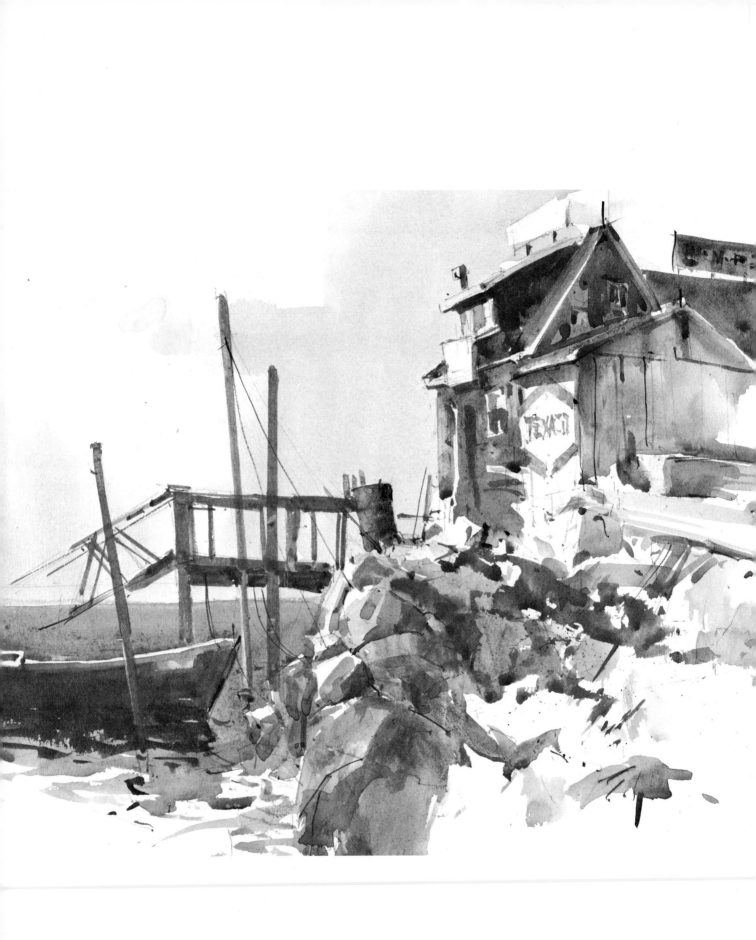

Croney on Watercolor

CLAUDE CRONEY

Text by CHARLES MOVALLI

NL North Light Publishers

Published by NORTH LIGHT PUBLISHERS, an
imprint of WRITER'S DIGEST BOOKS, 9933
Alliance Road, Cincinnati, Ohio 45242.

Manufactured in U.S.A.
First Printing 1981
Second Printing 1983

Library of Congress Cataloging in Publication Data

Croney, Claude.
 Croney on watercolor.

 1. Water-color painting-Technique.
I. Movalli, Chalres. II. Title.
ND2420.C75 751.42'2 81-18961
ISBN 0-89134-046-7 AACR2
ISBN 0-89134-041-6 (pbk.)

Edited and designed by Fritz Henning
Composition by Stet-Shields

DEDICATION:

To all my students

Contents:

Figure 1

Introduction

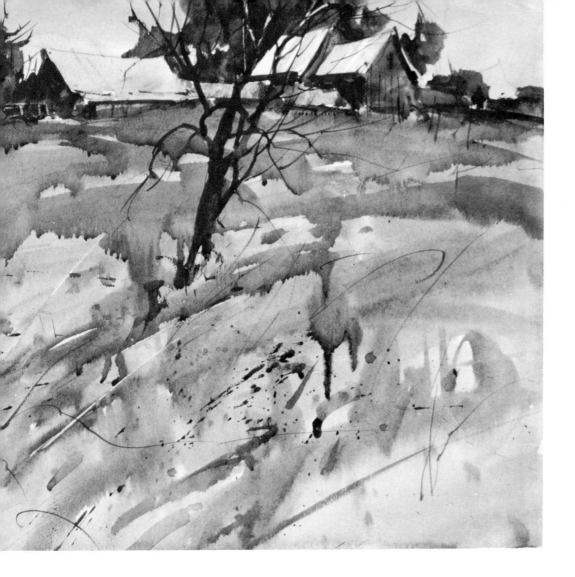

There are five basic building blocks in art. *Drawing* is the integrity of the work. It shows both the structure and, more importantly, the character of your subject. *Composition* is the strongest element in the work—it can be defined as "controlled variety." *Values* give the picture the illusion of reality. *Color* is directly related both to the facts of the scene and to your feelings about the subject. *Technique* is the "magic"—the aspect of painting students worry about most.

If you could dispense with any one of the five basic elements, it would be technique. It's the seasoning to the meal and, at most, adds only about 10 percent to the picture's effectiveness. The great Thomas Eakins didn't know how to handle watercolor technique as we do today. He used a single method throughout his work; he laid wash over wash till he got the color and value he wanted. No drybrush, no spattering, no frisket, no blotted edges. Yet his drawing and control of values made up for this simplicity of technique.

Although students worry about making their hands work, clever fingers don't really count for much. What is important are your mind, eyes and feelings. Expression comes from looking, thinking, experiencing, remembering.

Rules

Rules are meant to be broken. My high school art teacher told me never to "noodle" with a stroke. As a result, I never did the extra work a watercolor sometimes needs. The more "don'ts" you accumulate, the more you handcuff yourself. My only rule is: never do anything all the time. Instead of filling this book with "tricks," I'll talk about ideas that, for the most part, apply to either oil or watercolor painting. After all, my colleagues and I don't work alike. We don't even use the same medium. But we think in a similar way. We share a viewpoint. We worry about values, shapes, edges, and light and form. We understand each other and study one another's work. Using a few basic ideas, we all paint differently. That's what makes us professionals. And that's what makes art so endlessly interesting.

1 Materials

I'm not overly concerned about materials. If you worry about them too much you end up putting brushes and paper before the more important, emotional element of painting. So I'll just give you a few hints and suggestions—without going into a lot of detail.

Palette

I use eleven tube colors. I put all these colors out, *all* the time. I'd rather have a color ready, and not use it, than not have it when I suddenly find I need it. I also put out *more* color than I think I'm going to use. It's annoying to stop and squeeze out extra pigment halfway through the painting. By squeezing out *fresh* pigment when I begin to work, I give myself a better chance. Hard paint gives me trouble; using it wears out both my arm and my brushes.

The darker pigments dry the quickest and often need to be replenished; the umbers, Hooker's green, and the staining colors. The reds and yellows stay softer longer. When the paint gets hard and my palette is heavily encrusted, I soak it in a bucket of water overnight and wash it clean. This happens about twice a year.

The Pigments

Colors are a very personal matter. I'm always changing mine. I once used Prussian blue and cobalt; now I use cerulean and ultra-marine blue. You could paint with only the primaries if you wanted. In fact, it's good to try new colors; they wake you up and keep you from relying on a few familiar mixes. When I work I rarely think of color; I'm more interested in values, edges and design. The rest is dirty water—and a little of this and a little of that!

As you can see in Figure 2, my palette has 12 spaces and 11 colors. I use a lot of burnt umber and so have 2 spaces for it. The palette reads from left to right: from light to dark and, in general, from warm to cool. The colors are:

1 **Cadmium yellow pale.** I don't use much of this color; it's such a bright, pure yellow that it always looks out of place in a landscape. It can work in small quantities, but I mainly use it to lighten and brighten my greens.

2 **Yellow ochre.** This is a subdued yellow and, as such, is a more "natural" color. Since yellow ochre is related to both orange and the yellows, it can be used to modify either. The only trouble with yellow ochre is that it's not as transparent as I'd like. I often think of replacing it with the more transparent raw sienna. I never stop experimenting.

3 **Cadmium orange.**

4 **Cadmium red light.** A warm, light red.

5 **Alizarin crimson.** A cold, dark red.

6 **Burnt sienna.**

7 **Hooker's green deep.** This is a staining color. You can't wash it off the paper. It's so tricky that I sometimes tell students to omit it from the palette and mix their own greens. Once you've had some experience, you can try Hooker's. I use it as a "basic" green, modifying it with burnt umber or alizarin crimson. With the last, it makes a good dark, richer and less chalky than one made with, say, ultramarine blue and burnt umber. If I want a warmer dark, I can use more alizarin; if cooler, more green. That adds life to the mixture. Before you use this dark, however, be sure it's what you want. Once it's down, you're stuck with it.

8 **Cerulean blue.** Mixed with burnt sienna, this light blue makes a good gray. Since both pigments are light in value, I can use more pigment, without worrying about going too dark. The pigment is on my side. I like to use cerulean blue in shadows, modifying it with yellow ochre and sometimes a little orange.

9 **Ultramarine blue.** This is my dark blue; I seldom use it.

10 **Burnt umber.** Burnt umber is a warm color, but I've put it on the cool side of my palette because it's *dark*. Umber is very useful outdoors. It's handy for earth tones and in places where I need a deep, dark note.

11 **Payne's gray.** This bluish gray is a fairly neutral dark. Some of the other blacks seem to be either too lavender or too warm for my taste. I used to use Payne's gray in everything; now I use it very seldom. Payne's gray and yellow ochre create a muted green. Payne's gray is also good in a gray or rainy sky. I often add some yellow ochre to give the sky added glow.

Cadmium yellow pale	Yellow ochre	Cadmium orange	Cadmium red light	Alizarin crimson	Burnt sienna	Hooker's green deep	Cerulean blue	Ultramarine blue	Burnt umber	Burnt umber	Payne's gray

Figure 2
Palette diagram.

Color Mixing

I rarely use all these colors in the same painting. Many different pigments work against the picture's harmony of color. The six colors I use most are: yellow ochre, alizarin crimson, burnt sienna, Hooker's green, cerulean blue and burnt umber.

I do a lot of my mixing on the paper. If you do too much work on the palette, you mix your colors to death. Parts of the mixture lose their identity, and the result is dead and lifeless. You should also avoid the old trick of trying each mix on a piece of scrap paper before using it in the picture. The color may look right on the scrap—but wrong when you place it *in context*. It's hard to see a color against clean white paper. By making adjustments on the paper, you can see how the color looks in relation to what's around it. These adjustments often give an interesting variety to your washes.

"Mud" is usually the result of too much water in the mixes. Seeing how light the water makes his values, the student adds more pigment, scrubs it into the paper, and kills his color by repeatedly working washes into and over one another. Mud also appears when the student uses a light pigment in a dark mix. He may add cadmium orange or light red to his dark, for example, hoping the lighter color will add warmth and life to the mix. Instead, it lightens the tone and leads to frustrating at-tempts to regain the dark value. Use a *dark* warm color—like burnt umber—to give vitality to a dark area.

Opaque White

I never start a watercolor planning to use opaque white. If I need a thin, light line over a previously-painted dark, I consider the possibilities: should I lift it out, scrape it, or paint it in? If opaque white seems to me the best solution to the problem, I use it. I do whatever I think will work.

I should note that I haven't used Chinese white for years. When I need an opaque color, I use acrylic white. It's more opaque than Chinese white—the latter always seemed "watery" to me. When I tried to compensate by using the Chinese white more thickly, it would always stick to my brush!

Brushes

I use mostly round brushes (Figure 3). They have great versatility. You can spin the brush and point it quickly, and it's easier to draw ir-regular shapes with it. The flat brush sometimes

has too blocky an effect. Despite that problem, flats help to give the picture a *solid* look. The rounds work better on foliage, and when you want to draw rough, nebulous shapes.

Ox-hair is a good brush for a student. I drop down in sizes as the picture develops. It's like starting with a broom and finishing with a needle. Rarely do I use all my brushes in a picture—just what I need for the job. I also use an oil painter's bristle brush to lift out areas of color.

The best rule is: use the brush that fits the subject. A flat brush, for example, is a natural and easy tool for painting the angular planes of a rock. I could get a similar effect with a round. I could also use a screwdriver to open a can of beans. It's easier to use a can opener.

I've done more experimenting with the flat brush in the last few years. I used rounds because my teacher used rounds—and I never bothered to change. I've always used a big flat brush—like a house painter's brush—for broad washes. But I never used it to suggest structure. Habit kept me from the flats, just as habit keeps other painters from rounds.

I use a Strathmore 1-inch flat white sable. This brush has a nice spring to the bristles and is especially good on rougher papers, since it helps you fight the pebbly surface. I'm now planning to get flats in a variety of sizes.

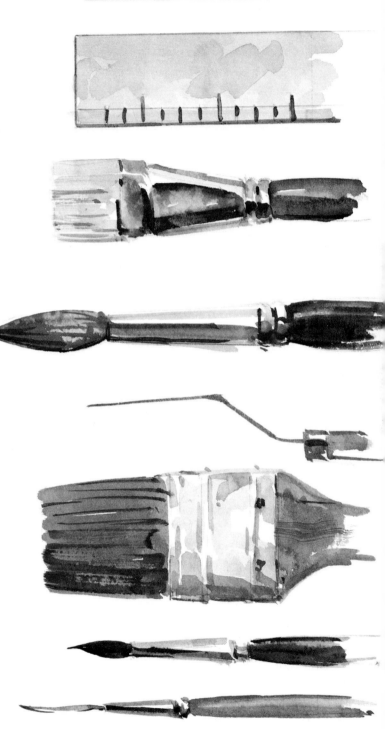

Figure 3

15

Figure 4

Drawing Equipment

I often use a palette knife to put in thin lines and to scrape shapes into wet paint. My knife is so honed through use that you can sharpen a pencil with it.

A ruler helps in drawing straight lines and can also be used as mahlstick.

A regular No. 2 pencil is good for drawing on the paper. It's hard, dark, and not too greasy. It feels right. Avoid a soft, greasy pencil; the lead flattens out and the water is actually repelled by the graphite.

You should also have a soft dark pencil for doing small compositional studies: from 4-B to 6-B. A hard pencil is too light; you can't get effective value contrasts with it.

A soft eraser can usually take care of any mistakes.

Paper

All papers have their good and bad points. With smooth, hot press papers, for example, the paint floats and runs along the surface. With rough papers, it sinks in; the paper acts as a blotter, and you have trouble controlling edges. Since paint slides over smooth paper and sets up quickly, large washes tend to streak. Despite this drawback, I think it's easier for students to start with a smooth paper. Rough papers lead to overly textured effects that often confuse and discourage the student. Rough papers also fight you; it takes more pigment and water to overcome the paper's tooth.

A quarter sheet is a good size for most experiments. You can control it better. But don't stay at that size too long. A half sheet is better; it's small enough to be manageable, yet big

enough to give you freedom. You can paint with your whole arm. Since it's a larger sheet, it's also more difficult. That's good. If you always paint small, you'll never have the courage to handle a full sheet.

I'd recommend using a fairly decent paper. Student-grade is fine for practice, but eventually you should get better grades. Personally, I like the papers made by Strathmore, Fabriano and Arches. I also prefer a white paper; it gives sparkle to the picture. Not all papers are white. Some are creamier than others; but you have to hold a white and off-white paper side-by-side before you can tell the difference. If you're interested, check one brand against another. Remember, however, that by handling your values correctly, you can make an off-white paper look brilliantly light.

Experiment with smooth and rough papers. Try different kinds. Don't get so used to a certain paper that you become a creature of habit. As I've already said: never do anything the same way all the time. When I go on a trip, I take both 140 lb. and 300 lb. paper—some smooth and some cold press. The variety forces me to adjust to the paper. Remember, too, that when you experiment, you don't always get good results. Don't panic. It's only a piece of paper. You can spoil it, but never waste it. Our mistakes are our best teachers.

You'll soon discover that paper is temperamental. On humid, damp days it buckles, and the picture remains wet until you get it back in the house. On windy days, the paper absorbs the washes almost before you put them on. With experience you learn to adapt to weather conditions. In Figure 4, I'm in Nova Scotia—painting in the rain. It was overcast when I started; it began to rain half-way through the painting. I didn't have time to worry. I just kept painting. When I got the picture home, I discovered that all the drips and runs enhanced it; they added to the wet feeling of the day.

Tape, Staples and Clips

I use masking tape to hold down the lighter papers. I staple the 300 lb. sheets. Clips are also good—you can move them easily when the paper begins to stretch. I don't think it's necessary to use the old-fashioned method of soaking and stretching. I remember going through that in high school. I'd let the paper shrink behind the stove. You can avoid buckling problems if you control the amount of water you use.

Water

I use a glass mayonnaise jar to hold my water. It's muddy by the time I get through with it. Sometimes the muddy tone is just the right color! Of course, part of the reason I can use "mud" is that I don't work with high intensity colors. I usually have only a few bright touches in a picture; nearby neutral tones set off their brilliance. These neutrals can be adjusted a dozen times without being dulled.

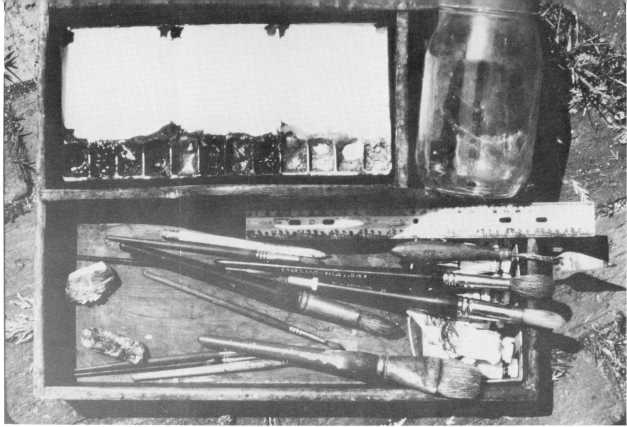

Figure 5
My painting materials nestle in an easily-carried wooden tray.

Conclusion

Some students feel that once they know the teacher's colors and brushes, they'll be able to paint with some of his skill. I used to read how-to-paint books, and I, too, always looked for the "magic." Did the artist use a grease crayon? Salt? Sand paper? Did he melt candle wax on the picture to keep areas white? But I've learned that too many tricks can lead to shallow pictures: pictures that are painted to use a technique rather than the other way around.

I spend half my time trying to *unteach* students; I have to stop them from worrying about rules and equipment. If you start with equipment, you often end up painting bad imitations of your teacher's pictures. And that's the worst injury a student can do himself. My development as a painter was held up for years by what "they say" about watercolor. You have to learn to leave the doors of your mind open, so they swing both ways. You have better results with less gimmickry—and more feeling!

2 Composition

Composition is central to good painting. A picture can have the finest color and technique in the world—but when it lacks design, it also lacks staying power. If you start with a good composition, however, you can paint the picture with an old putty knife—or the heel of your shoe. It will look good.

To compose, you first need to simplify. We all see too much. Our knowledge is fragmented. We strain to paint every leaf on the tree. The artist sees things as a whole, then worries about the bits and pieces.

Form versus Shape

We've seen how values create form—as in the light and dark shapes of a house. That's the "naturalistic" or "realistic" function of value and shape in a picture. But value and shape also have a decorative, compositional role to play.

This decorative role is the hardest for students to understand. Because of my own early experiences, I can sympathize with their problems. I was taught to use value contrasts primarily as a means to construct form. The method soon became a crutch. I couldn't paint unless a sunny, spotlighted effect gave me the contrasts I needed. I studied each sunlit object rather than the scene as a whole. There's a big difference between the two ways of looking. Seeing everything in 3-D, I tried to give solidity to each part. I never looked for the flat, decorative patterns that these shapes created. By looking for form rather than pattern, I didn't see the scene.

I had all kinds of prejudices. I was happy only on sunny days—and only in the early morning or late afternoon when contrasts were exaggerated. I've since learned that the only advantage to the morning is that your eyes are fresh; you're alert, rested and more sensitive to light. I made a fetish of getting out before seven A.M. I had trouble with blurred, noontime forms. And gray days were impossible. They lacked all form-creating contrasts. Yet I sensed that change was a part of the beauty of nature, and I should be able to paint under any conditions.

One day, as I struggled to analyze a gray day, I suddenly noticed that the landscape made an interesting dark *shape* against the sky. That doesn't seem like a big discovery, but for me it was an awakening. I'd discovered the importance of pattern and, through that, of composition.

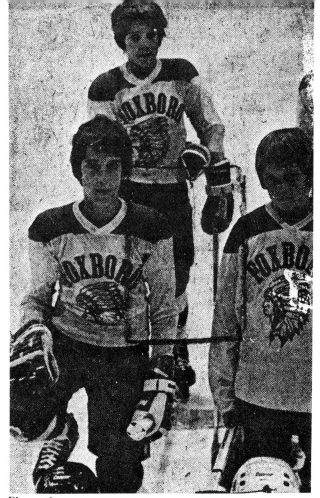

Figure 6
After cutting a reproduction of a photograph from the local newspaper, I used a mat to find an interesting value pattern.

Figure 7

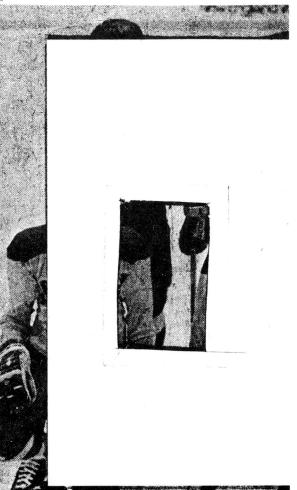

Looking for Patterns

As a preliminary exercise in thinking about patterns, sit in your living room and scribble with a pen. Look at the shapes around you. Squint. Search for the big light and dark patterns. Don't worry about individual chairs and tables. If your scribbles seem interesting, analyze why you like them. Is there an interesting variety of spaces? Or an interplay of different horizontal and vertical masses? If the scribbles aren't interesting, analyze that fact, too.

As a second exercise, cut a small mat so that the opening is no more than an inch or so in either direction—and move it over a picture from your newspaper. Use a black and white photo, so the color won't influence you. As you move the mat, look for variety: big, little and small shapes; light, middle and dark values. See if you can find shapes that interlock. Ignore the

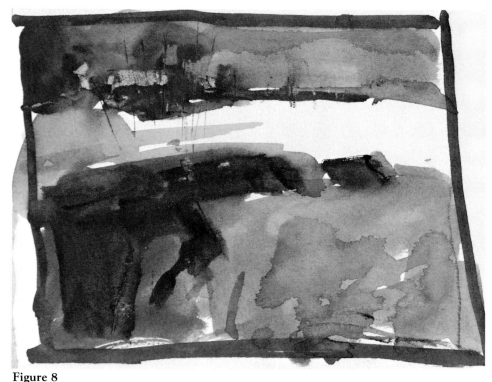

Figure 8
The matted photo was turned sideways and I made a quick watercolor study of the shapes from it. This wash drawing is small—only 3½ x 4½ inches.

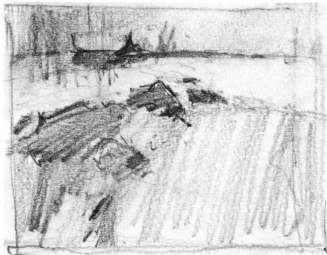

Figure 9
A small pencil sketch helps to refine and vary the shapes.

actual subject of the photo. In Figures 6 and 7 for example, I've matted part of a photo of some local hockey players. The selected area—only about an inch by three-quarters of an inch—shows part of their sweaters and gloves. Figure 8 is a quick watercolor version of the pattern. Once the pattern was established, I was reminded of a landscape. So I quickly scraped in the hint of a roof. I tried to let the shapes dictate to me, rather than forcing them into a pre-conceived format. Looking at this quick sketch, I felt the shapes were too regular. In Figure 9, I used a pencil to experiment with the shapes. Remember you are not responsible for what you start with; you are responsible for what ends up on the paper. In the final water-color, Figure 10, the dark areas have been broken up and variations added to the white shape, and a few details of trees and bushes included to give the viewer a sense of scale.

22

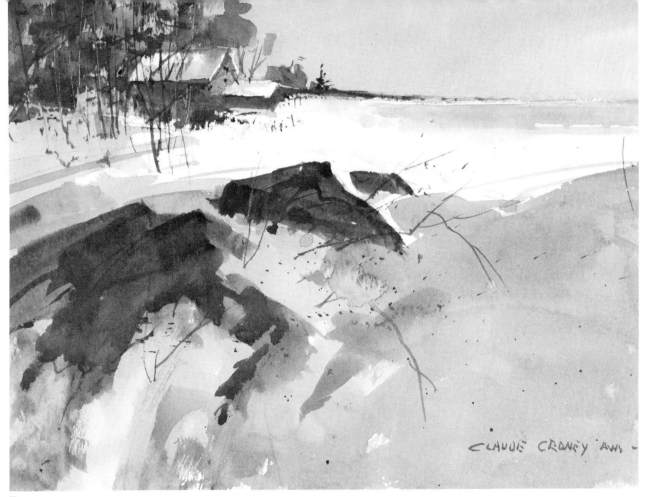

Figure 10
The final watercolor is based on the original photographic source. But I added hard and soft edges and used mid tones to break the masses into interesting patterns. For color see page 70.

I can't emphasize too much that these shapes and the patterns they make on the paper are *more* important than "subject matter." Long ago an instructor of mine saw me crowding a composition and said "take advantage of the paper." He didn't tell me to be more aware of the space I was working on—to use the paper, so that each line and shape becomes a part of the whole. It is an important consideration.

This principle applies whether I'm painting trees, barns—or a six-pack of beer. Don't say "house" to yourself; say "light shape" and "dark shape." Think of the big shapes first; then of the areas within those big shapes. See if you can find the character of the subject within these light and dark masses. Look sideways at a subject; look at it upside down. Do the shapes as shapes—and strive for interest.

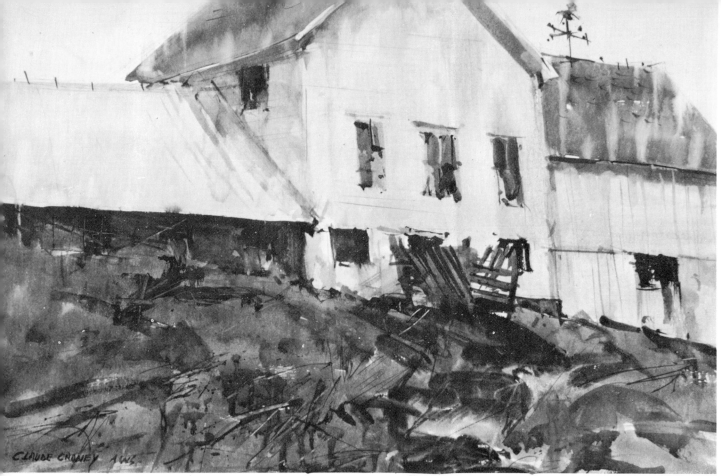

Figure 11
Since I liked the corn crib in front of the barn, I ran the building out three sides of the paper, thus reducing its importance. As I worked on the picture, it began to rain. You can see the spots on the right. Rather than panic, I took what nature had to offer. After all, if the picture doesn't work, I've only lost a piece of paper.

Patterns in Nature

Nature is full of interesting shapes—once you've learned to look for them. In Figure 11, for example, I was attracted to the roof and walls of the barn and used them in a way that divided my picture area into an interesting variety of shapes. You can see how each area is of a different size. Together they make an interesting pattern. Years ago I'd have been so busy trying to make the building look structurally "solid" that I wouldn't have noticed the pattern. Now the pattern is almost all I think about. In this picture, even the weathervane is part of the plan. I use it to break that section of sky to keep it from looking too much like the area of sky on the left.

24

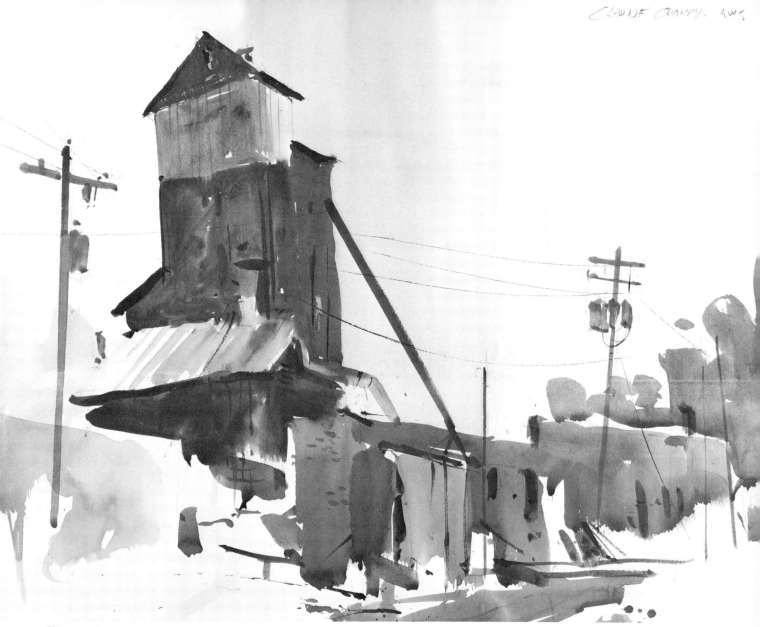

CLAUDE CROMEY. AWS

Figure 12
At this site, background hills were as high as the telephone poles.
They were distracting, so I left them out. I also tipped the grain
elevator, to give more excitement to the design.

Figure 12 was done at a workshop in Nebraska. Being unfamiliar with the locale, I told the organizer to take me someplace where I could see interesting shapes. I didn't care how junky the place was. In fact, I didn't want anything that was tailored or pruned. In this picture of a local grain elevator, I understated the background and structure and tried to introduce excitement into what was a straight and mechanical subject. Notice how the sky sections are each different in size; the telephone poles are of different shapes; the buildings are varied in contour. The simply stated round tree shapes contrast with the angular architecture.

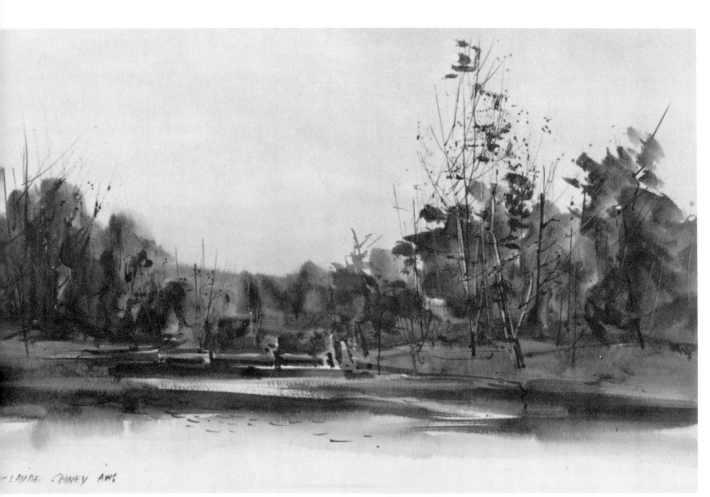

Figure 13
To give additional interest to this dull spot, I varied my technique, using dry brush for foliage, wet-in-wet for the sky, and calligraphic line for ripples in the water. Notice how the soft, wet-in-wet background recedes, while a few hard edges suggest the closeness of the foreground.

Figure 13 was also done at a workshop. In this case, I found the actual spot *uninteresting*. All the shapes were monotonous. In an effort to *make* something of it, I played up the trees, emphasizing and exaggerating their different heights and changing their contours so they'd break up the sky into more interesting shapes.

Of course, patterns aren't to be found only in buildings and trees. Figure 14 is of a much more modest subject: a simple, rustic fence. But I liked the shapes made by the posts. One is high; one, low. One overlaps the others. The shapes of the spaces *between* the posts are interesting and varied. And I like the *dark* shapes of the posts against the light grass, and their *light* shapes against the dark, distant trees.

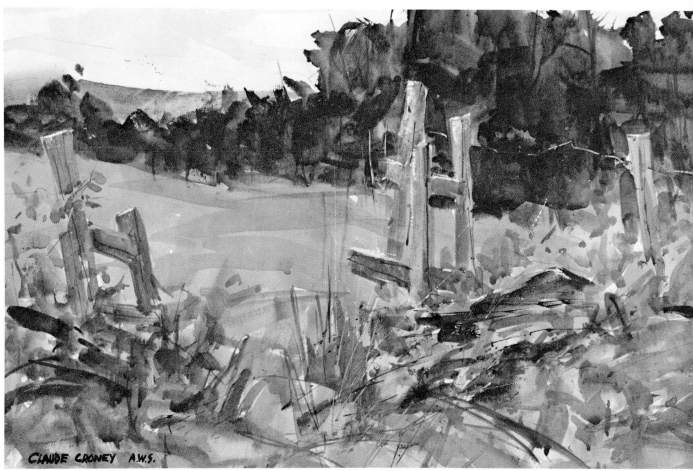

Figure 14
A gap in this fence was opened, so the viewer could enter the picture.
Distant birds help add a feeling of space.

Shape versus Detail

In order to emphasize the importance of shape, I sometimes force my classes to experiment by doing a picture in 25 minutes. This keeps them from being too finicky. If they want, they can take time with the drawing. But they can spend no more than 25 minutes on the actual painting. To be sure, their more meticulous pictures looked good close up; better, often, than the rapidly-done ones. But from a distance, the opposite was the case. In their more quickly painted pictures, the students went right for the big value and design pattern. These important shapes read clearly at a distance, while the more "finished" pieces tended to fall apart. The impact of the scene was lost in line work, texture and detail.

To show how much you can suggest with simple masses, I've included three pictures done for the Whiskey Painters of America, a group that always works at a very small scale. Each of these pictures is 2¾ × 4¾ inches. At that size, it's almost impossible to do detail. You must think in big patterns. In both Figures 15 and 16, I used a dark mountain area to set off the lighter sky and ground. A few roofs suggest buildings without my having to show much of the walls, windows and doors. The dark branches of the foreground trees read well against the light sky and explain the masses of trees in the distance. In Figure 17, the horizon is lower so you can see the shapes of the foliage against the sky. You know this is foliage without seeing individual leaves. A few dark branches complete the illusion.

Figures 15-16-17 →

When your paintings are smaller than a postcard, you haven't room for detail. These pictures suggest detail by contrasting large value areas to occasional dots, lines and broken edges.

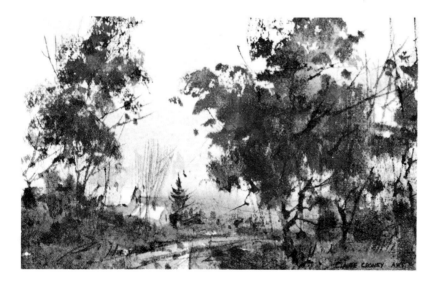

The Focal Point

Compositions usually have one focal point: that's where you find the strongest contrast, sharpest edges and brightest colors. With experience, it's easy to find focal points outdoors—but you first have to learn to "feel" a scene with your eyes. After years of painting, I am automatically attracted to strong contrasts. They affect me like a piece of sand caught in my eye.

Seeing shapes and contrasts makes painting much easier. I remember a student who had great technical troubles with the painting of a rock. Halfway through a class, he brought the picture to me and asked for help. In turn, I asked him if the rock he was trying to paint was lighter or darker than the background. He'd been painting it for an hour, yet he couldn't answer my question. He wasn't sure. He finally checked and discovered it was the *same* value as its surroundings. That's why he was having trouble; when everything is the same value, nothing stands out. Even a master would have trouble with such a subject.

So when looking for a natural focal point for your composition, think in terms of contrast. The eye slides softly over areas of closely-related value and jumps to the "rough," contrasty spots. You can see how the idea works in Figure 18. In this simple wash drawing, your eye skims over the areas of similar value and goes directly to the contrasts in the upper left. Notice that your eye isn't attracted by the "subject matter." It goes to the spot because I *make* it go there. It's attracted by the design elements of value, shape and edge.

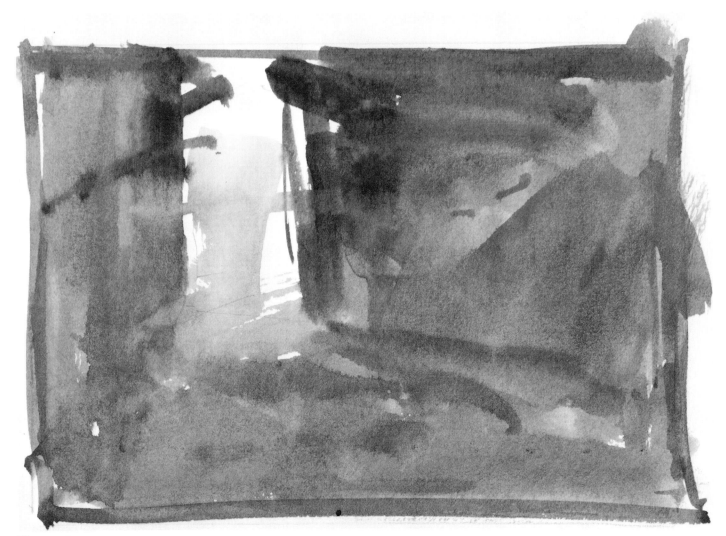

Figure 18
In this simple wash drawing, your eye naturally goes to the area of greatest contrast near the window.

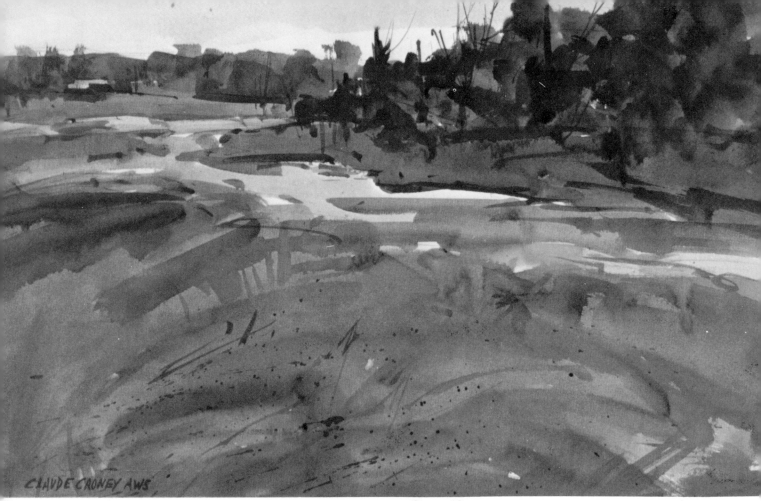

Figure 19
To emphasize the clarity and sharpness of the day, I use very few soft edges in this picture. Even the distant trees make a crisp contour against the sky.

In Figures 19 and 20, you can see how this compositional idea works in a relatively "realistic" way. In Figure 19, a sliver of white paper is the focal point for the whole picture: the gleam of reflected light on the water. The darks near this glare make it look even more brilliant. In Figure 20, I painted inside a barn at Kennebunkport, Maine, and was attracted by the light coming through a window. I saw contrasts and shapes—not the tools and junk. Since the main contrast is at the window, that's where I also have my sharpest edges.

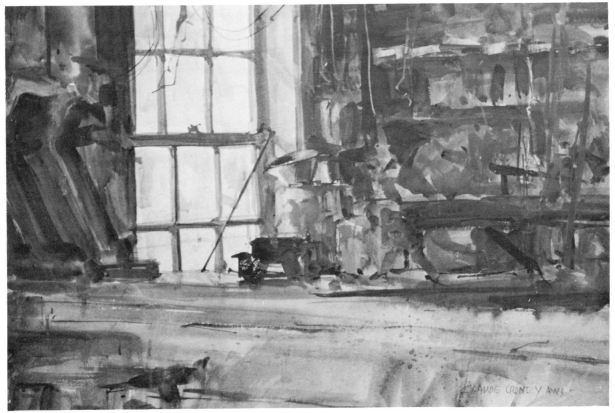

Figure 20
Here the oil can and funnel are large and varied in shape. They remain of secondary importance because they're related in value to the objects around them.

Edges

My handling of edges in Figure 20 was dictated by compositional questions—but also by a desire to be true to nature. Remember, our eyes have lenses with a varied range of focus. Things are sharp only where you look; glance around your room and you'll see what I mean.

In Figure 20, the edges are soft towards the corners of the picture. When you "feel" these areas with your eyes, you ignore the material on the shelves and go right to the window. I make it a rule not to paint what I don't see. When an object goes into shadow, students can't see the edge, but they "know" it's there and put it in anyway. As a result, their pictures have a hard, cut out look. Because of all the sharp edges, it's difficult for the viewer to determine the focal point.

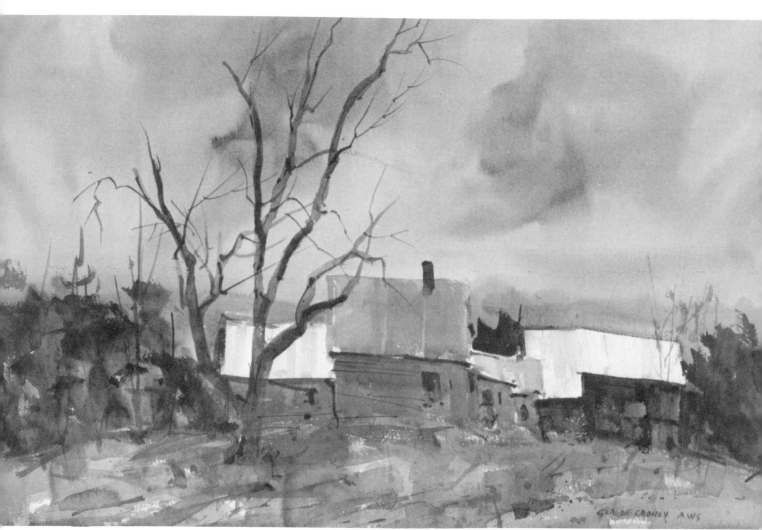

Figure 21
The large, foreground tree is an important vertical movement, balancing the dominant horizontals of the buildings, hills and field. The tree also overlaps the house, setting it back in space.

In Figure 21, I was struck by the way the overcast sky threw light on the angular roofs of the buildings, my focal point. To emphasize the edges of these roofs, I use color and value in the foreground rather than harsh lines. Buildings and grass merge into one another, making the sharp edges of the roofs all the more telling.

Figure 22 represents the problem of painting a single boat. I want to make the boat a *part* of the space that surrounds it. And I do this by my control of edges. If I had a sharp edge all around the dory, it would look too static. Notice, instead, the soft edges near the seat and the stern of the boat. The craft merges with the environment. The highlight on the boat is broken and elusive; it's sharp in some

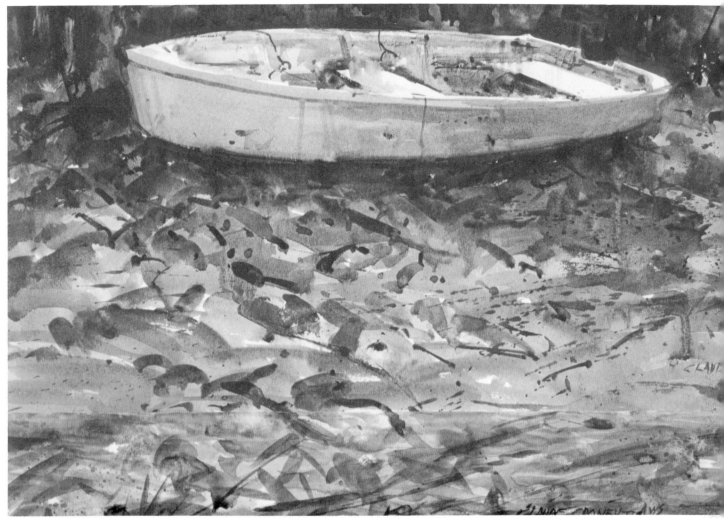

Figure 22
My subject is the top-lit plane of the dory. Everything else is secondary to it. A variety of strokes were used to suggest the vertical sides of the boat and the uneven, broken movement of the land.

places and soft in others. The edge where the boat meets the ground is also blurred. This looks simple, but it was hard work. I added strokes, dampened them, and teased them till I got the effect I wanted.

How you handle edges has nothing to do with your "style." If you like detailed work and want to show every brick, that's OK. But some soft edges will help you avoid stiffness and monotony. Similarly, if you work loosely and have lots of soft edges, there's a danger your pictures will look vague and wishy-washy. You need some hard edges. When everything's soft, the picture is mushy; when everything's hard, it looks brittle and cut out. As always, the important consideration is *variety.*

Emphasis

Although I don't think of myself as a "realistic" painter, I like to relate to reality and so I always try to stick to the truth of value. But I'm not a camera. I'll exaggerate a value if that will improve a composition. In fact, most of my pictures are either overstatements or understatements. I overstate values, looking for the big light and dark pattern—and understate the details. I avoid wholesale lies, however, since that's where you can get into trouble. Usually, students try to compensate for their "lies" by drawing more details. They hope to shift attention from what is basically a false value relationship. Yet such additional details seldom make the picture look real or right.

In Figure 23, the glare on the window is my only spot of white paper; because of its lightness, contrasted to the adjacent dark shadow, it immediately attracts the eye. Yet, at the site the patch of sky to the right was almost as light as the reflection. If I'd painted it "truthfully," I'd have lost the impact of my focal point. By running a darker wash over the sky, I kept attention where I wanted it.

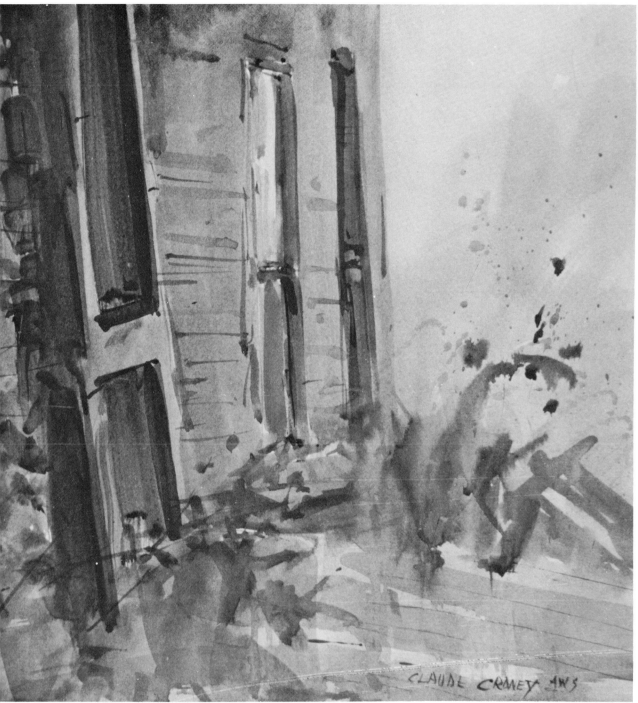

Figure 23
The angle of the old door adds interest to the scene. The brilliant glare on the left is balanced by the thin windows and the suggestion of a bush to the right of the screen door.

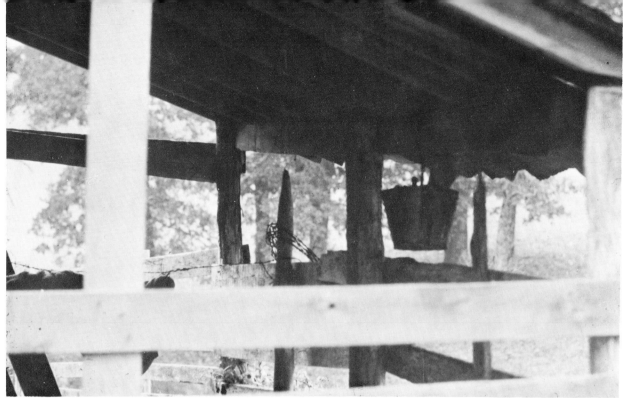

Figure 24
At this site I was struck by the way the dark shape of the pail stood out from the light background.

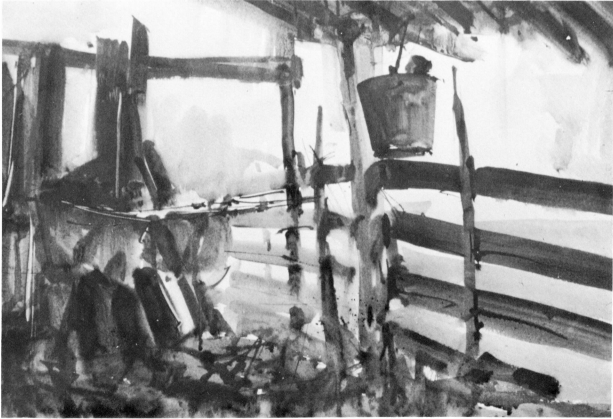

Figure 25
In the final watercolor I omitted the confusing foreground fence and emphasized the play of horizontal and vertical elements. The subject reminded me of Mondrian.

Figure 26
The problem in this picture was to make the background interesting without detracting from the wood pile. I used texture in the building, but kept the values related, thus making these details less noticeable.

Figure 24 is a photo of a site; you can see that the brightest light is at the extreme left *and* the far right. In the painting (Figure 25), however, I moved the light area in back of the pail and reduced the light values in the left and right sections of the background. This centered the viewer's attention on the pail. At the same time, I introduced some value changes in the distance, giving it sufficient variety to make you feel you can walk into the landscape. If the background were a solid value, there would be less feeling of space. By keeping the values close together, the distance almost disappears and doesn't compete with the pail and the fence posts.

There wasn't much to paint at the site of Figure 26. But after looking for awhile, I saw a pile of logs near a white barn. I liked the light on the wood—but the structure behind it also received a strong blast of sunlight. I had to make a choice: tone down either the building or the logs. I kept the emphasis on the logs because I liked them; the background building wasn't an exciting shape. Now the snap is all in the foreground, with just a little interest in the upper part of the picture; clapboards, windows and a tree add interest to the area.

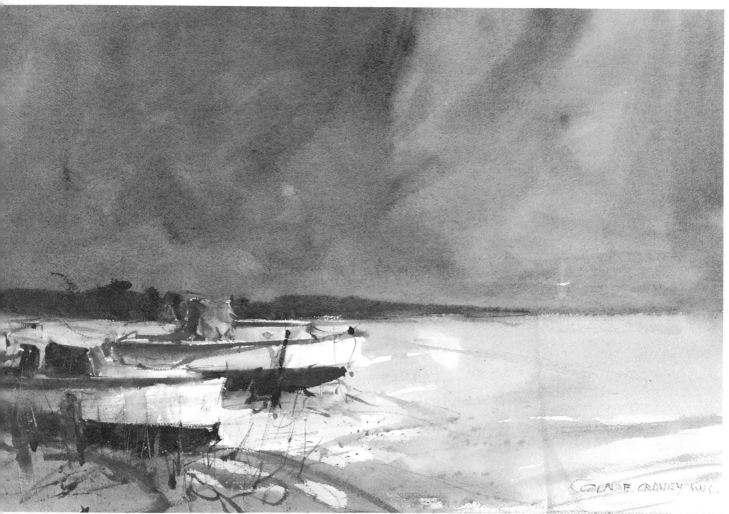

Figure 27
By cutting grass across the foreground boat, it becomes subordinate to the farther one—the center of interest. Shifts in value add interest to the large expanse of sky.

Figures 27 and 28 present similar problems. In Figure 27, white boats and white snow were *both* lit by light from the right. I ran washes over all the whites except the ones I wanted to emphasize. I didn't add these final washes until the end of the painting process. By that time I'd decided to emphasize the boats—that's where I have my main contrasts, brightest color and sharpest edges.

In Figure 28, I'm interested in the highlight on the mud flats, and especially in the light, glistening reflection on the distant water. I toned the foreground highlight slightly so you could better see the distant glare; then I made this bright area all the more vivid by showing it against the dark shapes of trees and rocks. I put

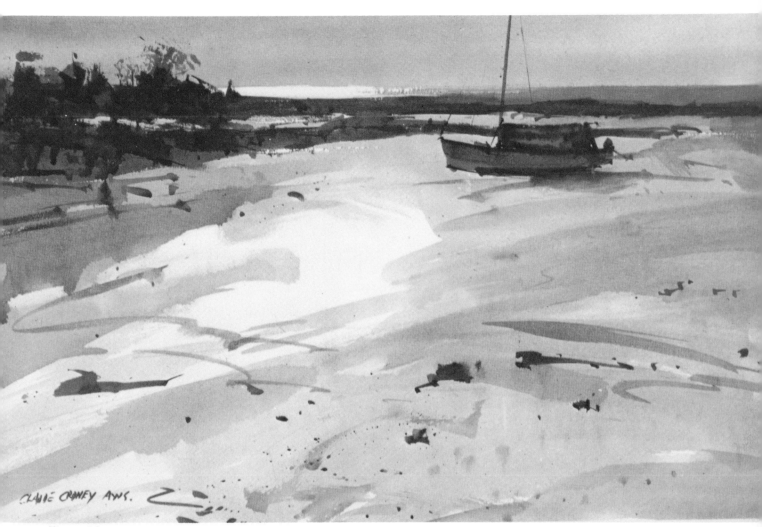

Figure 28
The small boat in this picture makes it clear to the viewer that he's looking at a mud flat. The mast goes out of the picture, creating a strong vertical element. The dark silhouette of the boat helps balance the large land mass on the left.

a few details in the foreground to help bring it forward. Students often have trouble with such expansive foregrounds. They want to fill up the space, but they're afraid to put grass or leaves in the center. And they sense that too much detail in the corners would be an even greater distraction.

In Figure 28, I have some detail—but notice how I bring the nearest strokes right out of the bottom of the picture. That helps give the viewer a sense of space beyond the frame. The degree of finish given to the center of interest dictates how much finish we want in the rest of the picture. Here the trees near the sparkling water are so simply painted that a detailed foreground would be a distraction.

Figure 29
At this site, both the sky and the roof of the building were very light. Either one could have been emphasized. I decided the sky wasn't interesting enough to be pure white and reserved the unpainted paper, instead, for the glare on the shingled roof.

Movement

A good composition contains a variety of movements; horizontal, vertical and diagonal. One is usually dominant, with the others creating variety and interest. Figure 29 is clearly a horizontal picture. The vertical telephone poles provide a needed relief. Notice that these poles tie the horizontal bands together, thus adding unity to the composition. They also lead you back into the picture space. The largest pole cuts across the house, forming a cross that marks the center of interest. In Figure 30, on the other hand, the hanging coats give the picture a strong vertical movement. This movement is relieved by the horizontal line of the sunlit shelf.

Figure 30 →
Here the main area of white paper is near the flowers; the area dulls in value as we move to the left. Students usually try to see too deeply into shadows. Here the shadowed coats are indistinct and mysterious.

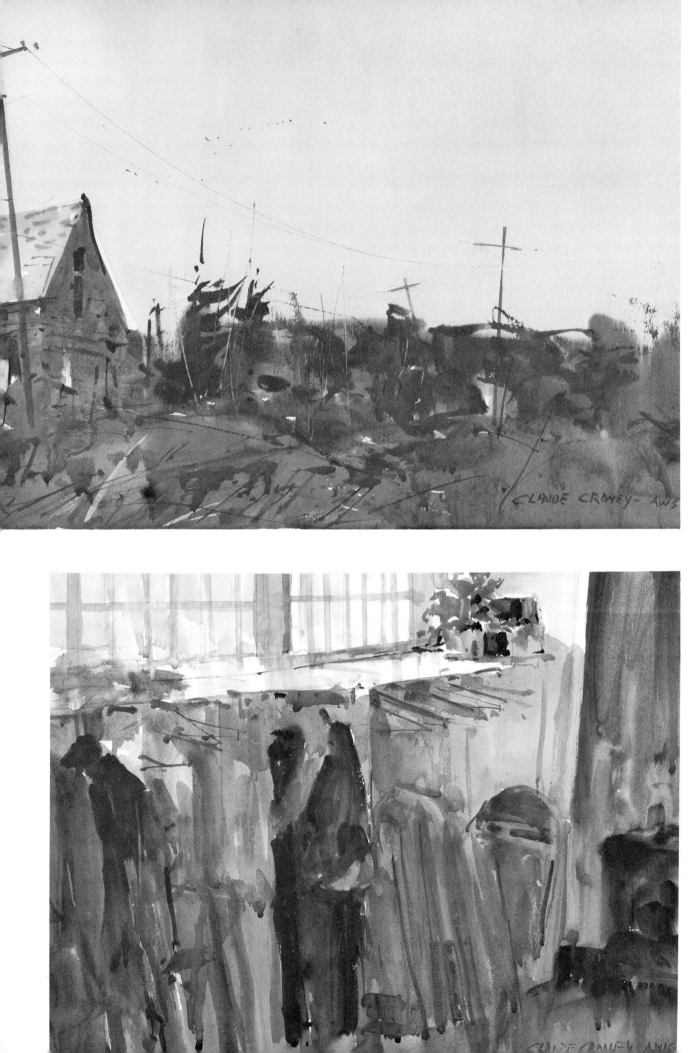

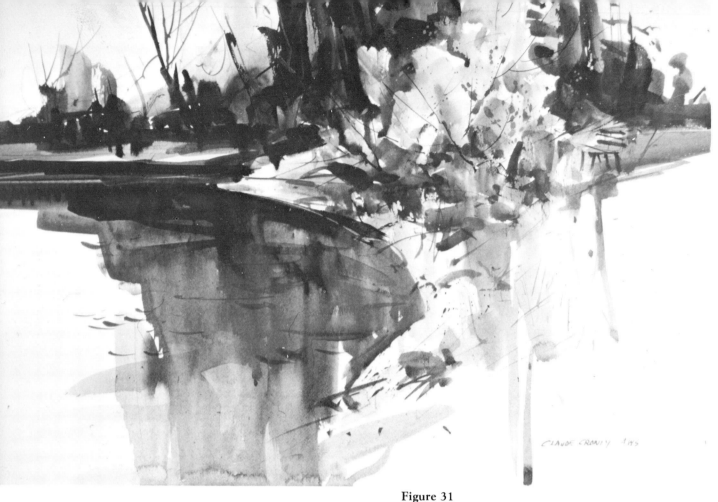

Figure 31
Since I'm dealing with a natural—rather than architectural—subject, I only worry about drawing the big areas before I paint. The brush does a lot of the work. Spatter, washes, and hard and soft edges add textural interest.

There were lots of bushes, trees, rocks and other distractions at the site of Figure 31. I picked what I liked. I used vertical strokes for the trees and their reflections in the water. Then I broke up the surface of the pond with a few horizontal lines. Along with the distant bank, these lines counteract the verticals of the design—they also serve a descriptive function, emphasizing the flat surface of the water.

At the site shown in Figure 32 I was struck by the height and strength I felt when looking up at Falmouth Lighthouse. The lack of activity at the spot further emphasized the overall feeling of sobriety. In the painting (Figure 33), I emphasized the strong verticals of the subject by cutting off the top of the tower. I think this makes you feel as if you're looking up at the structure. The horizontal line of the roofs, fences and ground sets off this vertical thrust.

In Figure 34, I was again struck by height—this time that of a seaside building and, especially, its long pilings. The tide wasn't as far out as I show it. I lowered the ocean—like pulling the plug out of a bathtub. I then lowered the horizon, too—that further emphasized the pilings' height. I also painted the sky with broad, vertical strokes. These insistent vertical lines are balanced by the horizontal line of the distant land, the boats, and the wharf itself. Notice how I've even introduced horizontal lines within the vertical mass of the pilings.

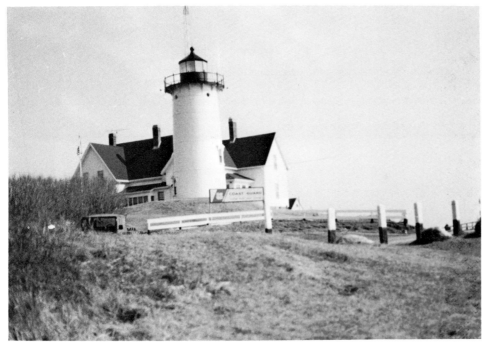

Figure 32
A photograph of the lighthouse at Falmouth, Massachusetts.

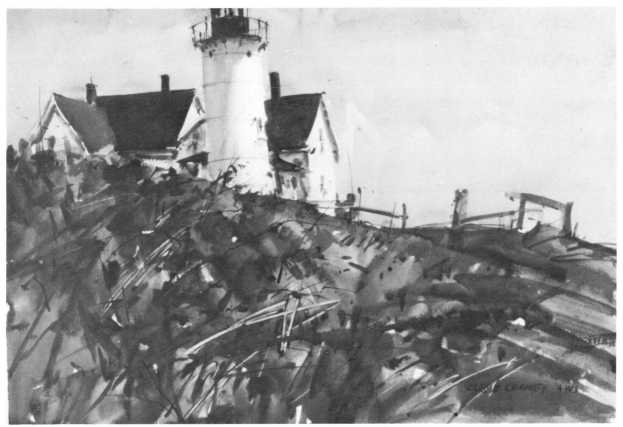

Figure 33
I simplified the site by eliminating the flag and the Coast Guard sign. Also ignored is the white fence, keeping the sparkle of the paper for the building and tower. Diagonal strokes suggest the wind blowing through the grass.

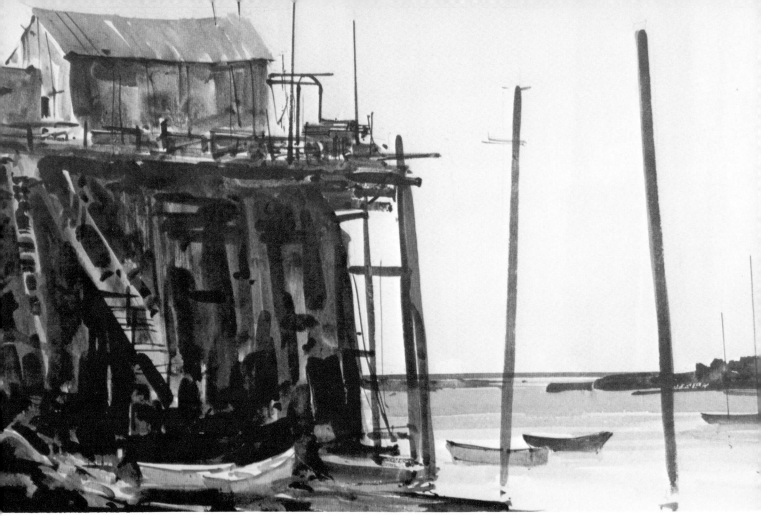

Figure 34
The small boats in the picture give interest to the area of water. They also add weight to the right, balancing the heavy mass on the left. The tall, free-standing pilings help balance the picture.

Weight and Balance

In many of the preceding examples, the focal point is somewhat off-center. This creates an asymmetrical design that usually offers more visual excitement than formal symmetry. Yet, for reasons unknown, students often use the more formal, static balance. If they have a big tree on one side of their paper, they sense that the area is too "heavy." So they put a similar tree on the other side of the paper. That looks too balanced so they add a bush to the other corner. This again unbalances the picture; a similar bush is added to the opposite corner.

On it goes; the more they try to make things different, the more they remain the same.

All that's usually needed to balance a weight on one side of a picture is a small mass on the opposite side. In Figure 35, I have a land mass and a large building on the left of the paper. The delicate lifeguard's chair is more than enough to balance them. Also, the glare on the water behind the chair helps balance the distant, dark mass, but it is also clear the chair is the center of interest.

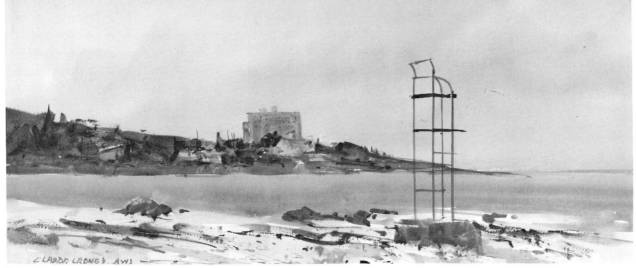

Figure 35
Here the tall chair interrupts the eye's natural movement from left to right. It also unifies the design by tying the foreground, distance and sky together.

Figure 36
This small wash drawing was made from imagination. The idea was to create a balanced and varied value pattern.

Conclusion

I once read that abstraction is "harder" than realism because a realist can leave a tree out and still have a landscape—while an abstract painter, if he leaves something out, ruins his picture. Yet, in realistic as well as abstract art, *all* parts must work. Shapes make the subject; and if the shapes are bad, the picture will be a failure.

In Figure 36, for example, I was trying to determine an idea for a painting demonstration—using only my memory and imagination. It's just an abstract doodle, done in washes without any preliminary drawing. As I worked, I sensed the beginnings of interesting horizontal and vertical movements. I emphasized that idea in Figure 37. I also paid more attention to spa-

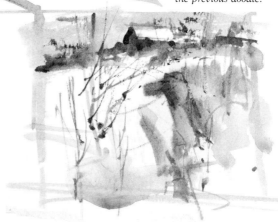

Figure 37
Here I developed the vertical and horizontal movements suggested by the previous doodle.

cial divisions and added a little texture: line, mass and dry brush work. Figure 38 is the final idea for the demonstration. I broke up the monotony of Figure 37 by having the rock cliff dominate the picture. The trees are less important, and the barn is reduced to an interesting dark spot.

The point is, it's easy to do a "nice" picture, with "nice" apples, a "nice" dish, and a "nice" bouquet of flowers. But it's much harder to create a unified pattern, a pattern in which all the parts fit together. You shouldn't worry about whether your subject is "picturesque"! If there are boats around you, paint them. But, if all you have are trash cans—paint them, too. When I lived in the city, I'd go to the top floor of my building and paint looking over the town; I'd do roof tops, chimneys and porches with clothes on the line. I'd go down into my basement and paint the coal, the cellar window and an old cider jug. The problem is the same: how to put together shapes and values in a way that will *work* as a pictorial design.

When you think in compositional terms, you can no longer use the excuse that "it was there, so I put it in." You're responsible for what you put on paper. As you work, there eventually comes the time when you pay less attention to the scene and more to the needs of the picture. The subject can't tell you everything. You have to learn to "listen" to the picture.

This may sound cold-blooded. After all, what about the "mood" of the subject? Mood is the *last* thing I think about when painting. If I go for the big shapes and values, mood follows on its own. It's those big shapes and values that create the mood. Andrew Wyeth, a great painter of moods, considers himself an abstract painter. He thinks of the big shapes and patterns *first*.

Composing a picture is like trying to guess the right sequence of numbers in a sweepstakes—or like playing chess: if I make this move, how will it effect everything else on the board? Interest is added by the fact that there are no hard and fast answers. We're told never to put anything in the middle of a composition, for example. And that's a good rule. But Leonardo da Vinci put Christ in the exact center of his Last Supper. And it works!

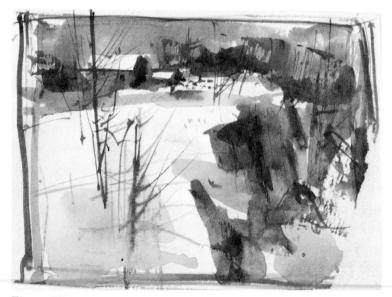

Figure 38
Once the basic scheme is established, I begin to refine it, working for variety and balance within an overall unity.

3 Values and Color

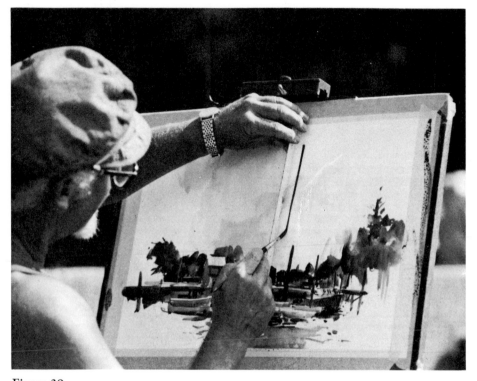

Figure 39
By keeping the paper vertical and out of the light, you can better judge values.

Two of the most important elements in painting are value and color. The two are closely allied. Every color has a value; and every value a color. Whenever I look at an object outdoors, however, I first ask myself what *value* is it? Value comes first.

In a previous book I talked about my "three value" approach as a way to simplify what you see. Objects can be viewed as a light, a dark, or a middle value. All the lights belong in the light family; all the darks, in the dark family. At the time my first book appeared, friends asked me why I used only three values. Why not seven? Why not ten? But if you work with too many values, you can waste all day deciding if a tree shadow is a "7" or "8" on the value scale. It's a lot easier to make what's light, light and what's dark, dark—and not to worry about subtle nuances. Aiming at a few big targets, you're more likely to hit them.

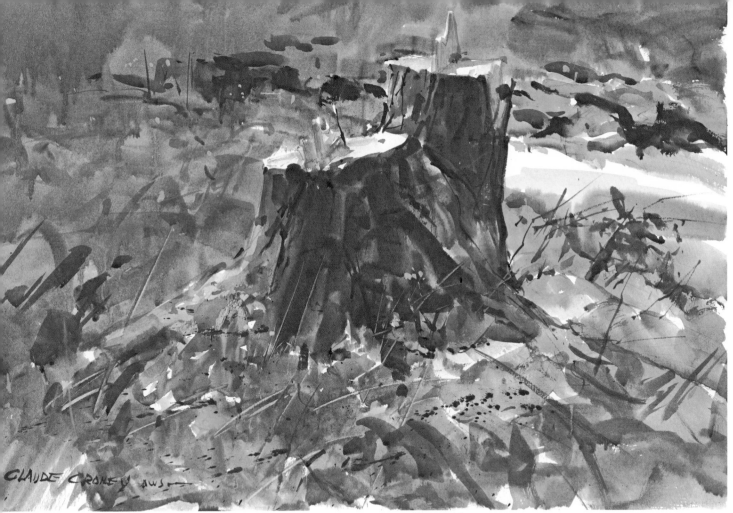

Figure 40
In this picture, all the detail is in the immediate foreground. The distance had grass, rocks and other textures. But I kept it simple in order to focus interest on the nearby tree trunk.

In Figure 40, for example, I was struck by an old tree stump and some nearby glistening water. On that day I didn't feel like painting the whole countryside. The stump is a dark value; the grass is a middle value; and the water and top of the trunk are light. There were lots of value changes within these areas, but I squinted and tried to get the masses first. I opened my eyes later and added whatever value shifts I thought necessary to give objects their own particular character.

In Figure 41, the idea was to capture the feeling of trees on a hillside without actually drawing them. In order to suggest such a complicated subject, I studied the way the groups of trees formed large value masses. In the foreground you can sense a few individual trees; in the middle distance they become part of a general, dark value. The same approach, by the

50

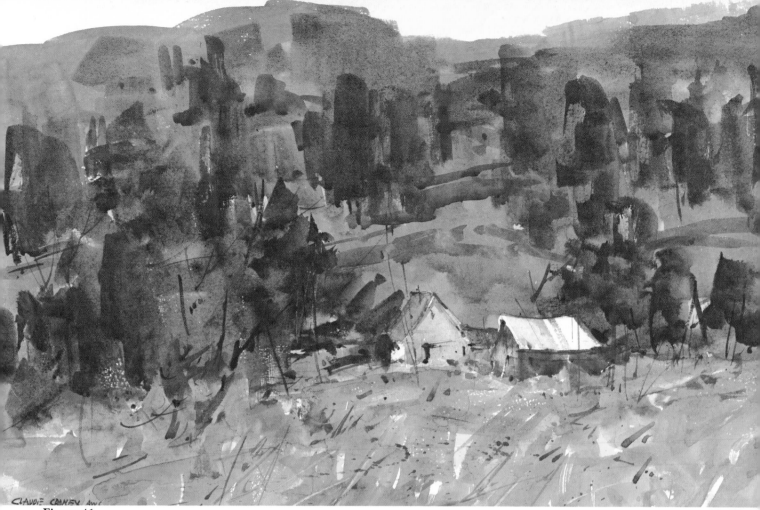

Figure 41
I keep the trees in the middle-to-dark value families, giving the structure's sunlit roofs a chance to register. Interest is added to the barn roof by toning part of it with a darker value.

way, was used to paint the foreground. You can see blades of grass near the lower border; but they become a simple value mass as they near the distant buildings.

Detail

It's amazing how little detail you need, once the big areas of value have been established. When I was a kid I often bicycled past a pawn shop. One day I saw a picture of a big, three-masted schooner with a dory floating nearby. The shopkeeper knew I was interested in painting and told me to take a good look at the small dory. Up close it was just *a single* brushstroke. But the artist had the right value in the right context; he could have made the stroke with his elbow, and it would have looked right.

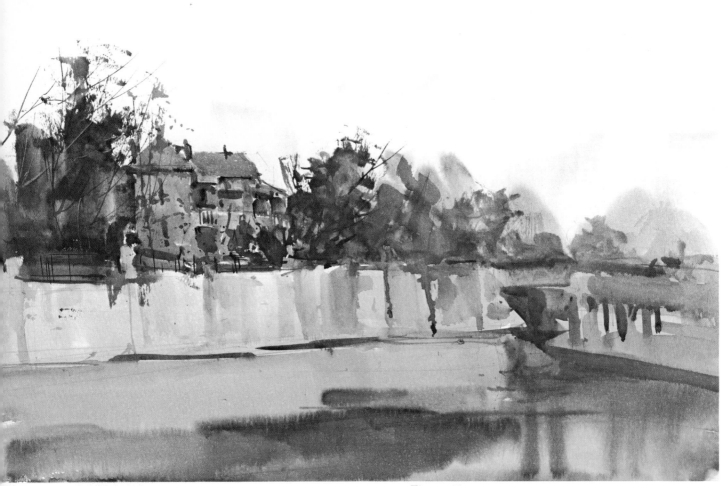

Figure 42
I used two different techniques in this picture. For the sky, I first dampened the area with clean water and painted color into it; as the color bled it created delicate, soft edges. I dampened the foreground by running a wash of color over it; then, before the wash dried, I worked other lighter and darker colors into it.

Students worry too much about technique and texture; about finesse, accuracy and facility. Sometimes I tell right-handed students to paint with their left hand. That takes away one sense: the ability to "get things right." Then they start thinking about values. I am right-handed, and once made the point by doing a class demonstration using my left hand. If you get the values right, you can paint with a shoehorn!

In Figure 42, I take advantage of the way values can suggest detail. Painted on a rainy day in Texas, this picture has less value contrast than Figure 40. Again, I analyzed the scene as a series of different value areas. Once these were established, I needed very little detail to "explain" my subject. The house, for example, has a few darks to suggest eaves and windows. A few value changes suggest a retaining wall and a bridge. Shifts in value also indicate different trees and the quality of the atmosphere.

In general, I try to use the whole value range in my pictures, from the darkest dark up to the white paper. The nature of the day determines how far I can go. This use of a wide range of values is characteristic of watercolor. Oil painters usually take a bit off each end of the value scale; but watercolorists often stretch the range, getting snap in their pictures by contrasting their rich darks to the white of the paper. In watercolor, you may even be in trouble if you stick too close to the middle of the value range. Your work begins to look pale and washed out.

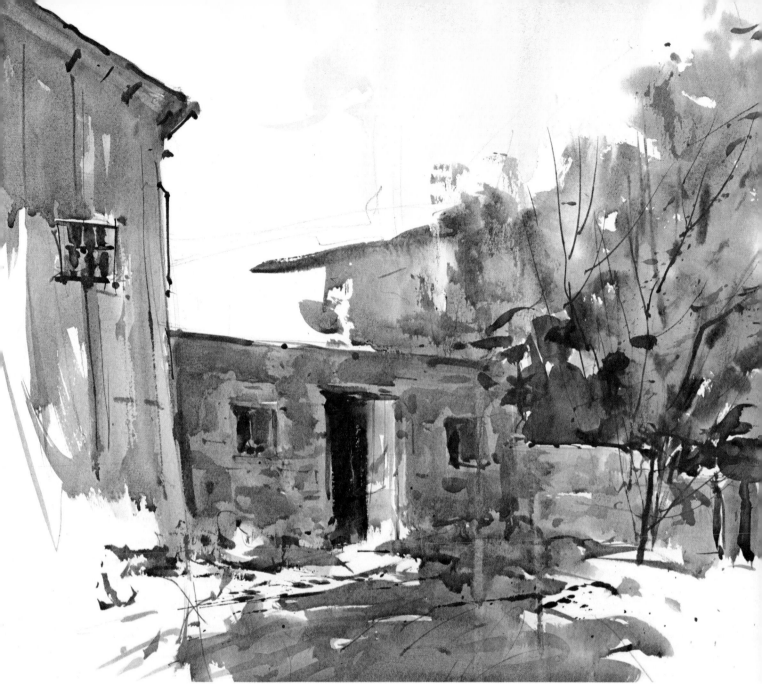

Figure 43
On this overcast day, walls, roofs and trees form a dark silhouette against the light, gray sky. Notice how these elements all slant in different directions, adding a note of dynamism to the design.

Judging Values

To judge values properly, you have to make comparisons. I always look for the lightest light and darkest dark in a scene and compare everything else to them. I pick the most obvious values, because I know I can be *sure* of them. If I have a problem on the paper, I ask myself questions: if object "A" is the right value in the picture, and "B" is also right, then how dark or light is object "C"? Maybe it's lighter than "A" but darker than "B"—so I know where it belongs. The first values you place on the paper act as a gauge for the later ones. But these first basic values must be right. If you go too dark or light, all your relationships will be off; and you'll find yourself somewhere up or down the value scale.

53

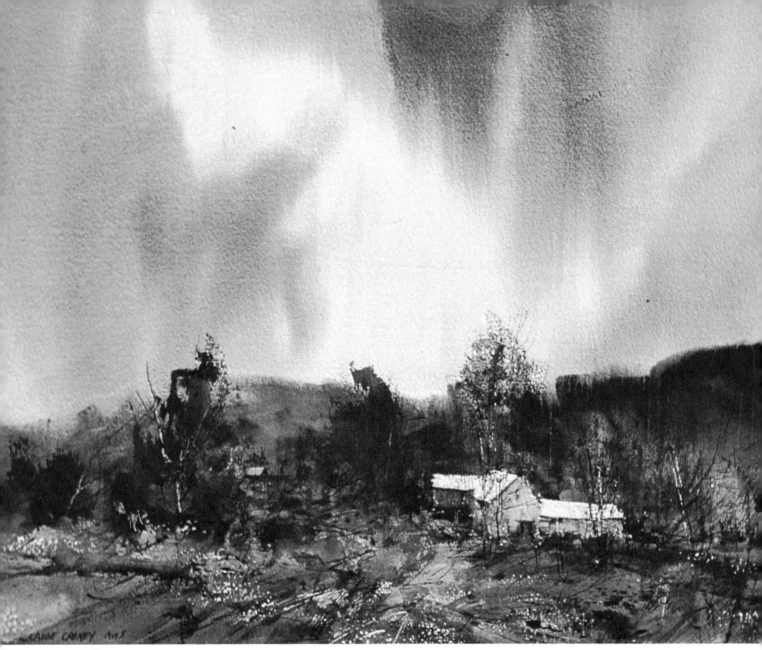

Figure 44
The brilliant, angular shapes of the roof suggest the building without my needing to draw it in detail. I added just enough to tell the viewer he's looking at buildings—and not a lake.

In order to get accurate values, I work with my paper almost vertical and out of the direct light (Figure 39). When the light is on the paper, the resulting glare can hurt your eyes. It's hard to see values. In fact, a dark always looks like a mid tone on sunlit paper. Let the sun hit a piece of black paper, and you'll see how light it looks. A dark painted on sunlit paper always appears unnaturally black when viewed indoors. You could play it safe and work your pictures up in a series of gradual washes, one darker wash over another until you get the right value. But I like to work directly. If an object says "dark," I go dark; if it says "light," I go light.

Relationships

Students have trouble seeing the truth of basic value relationships because they think they "know" how objects look. On a gray day, for example, a white church steeple will be

darker than the sky—but the student "knows" the steeple is white and so rarely makes it dark enough. Figure 43 is an overcast day. Many students think such a day is "dark" and assume the sky must be dark, too. In reality, the sky on such days is rarely dark. As in this illustration, it's often the lightest part of the scene.

In Figure 44, there's no question that the sky is dark; I was attracted by its dramatic character. Painting it, I ran into technical problems. My first strokes frightened me—they looked almost black against the clean, white paper. Seeing this, some students would immediately panic and throw on more water—thus losing the dramatic effect. But I knew from experience that to make the sky look light, I needed to put a more intense, darker value next to it. The effect of a value always depends on what values are around it. Everything is relative. The minute I added the dark mountain, the sky looked light and airy.

Many student problems come from the failure to see such basic relationships. One of my students showed me a picture he'd painted in the winter. He felt something was wrong with the design, but he didn't know what it was. The sky was good; so was the snow. But together they didn't work. We discovered that, thinking snow was "white," he'd left it much too light. His light snow made the picture look as if it were lit from the front, while his light sky made it appear to be lit from the back. Something had to be subordinated, and he finally threw the snow into shadow. His problem wasn't a complicated compositional one; it was centered on misjudged values. A few strokes and the picture made sense.

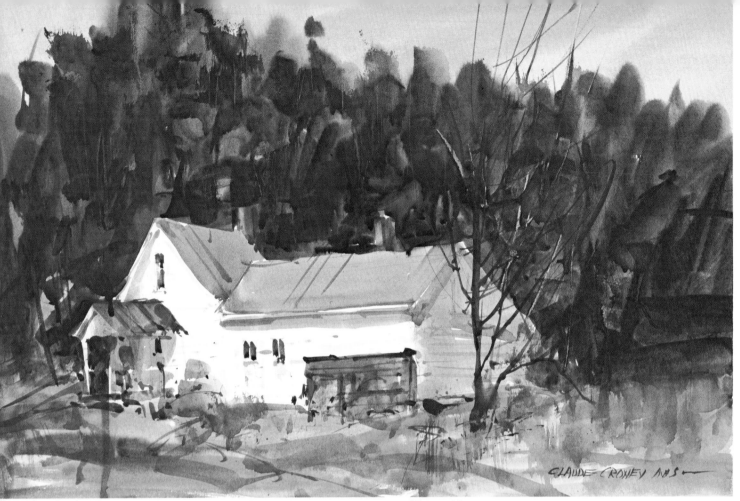

Figure 45
In order to take full advantage of the white paper and make the sunlit house appear bright and luminous, I contrast it to the dark background. The sky is also light, but I purposely reduce its value to help emphasize the building.

Another common student problem is that of going too black in the shadows. Students again "know" that shadows are dark and sometimes exaggerate them for effect. Yet the shadow of an egg is hardly black—and a lump of coal has light and dark areas. Even the black squares of a checker board, catching and reflecting the sun, can appear as spots of light!

Figure 45 was painted on a bright, sunny day. Notice, however, that the shadow side of the building isn't dark; if it were, the feeling of a white house would be lost. In fact, this shadowed side looks even lighter because of the dark tree that runs across it. Figure 46 was painted on a gray day. There's no sun, and all the light is diffused through the sky. Yet the building shows a value change from one side to the other. The right side of the house is a bit darker than the front because it's in the shadow of the nearby fir. Even on a gray day the trees filter light from the sky.

Observation

Values are right in front of us, but our prejudices make it difficult for us to see them. To observe them, we have to use our heads as well as our eyes. When you go outdoors, study how nature works. Ask yourself questions. Why is a

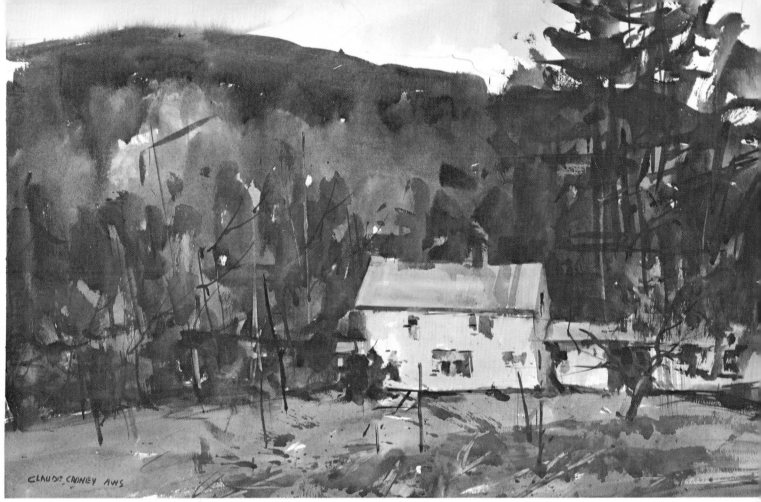

Figure 46
On gray days, the value difference from one side of a building to the other can barely be seen. I often introduce a value change anyway, exaggerating it to give the building added dimension. In contrast to Figure 45, the only piece of white paper in the picture is in the sky.

white house different values at different times of the day? Seen against the sun, a white house receives little light and can be relatively dark in value. When the sun is directly overhead, the horizontal planes of the ground and roof will bounce light into the shadowed walls, making them lighter in value. Late in the day, the low-lying sun might hit the vertical walls head on. Thus brilliantly illuminated they are very high in value.

It may help to see these value changes if you look at each area through a hole you form with your hand. Pretend you're peering through an imaginary spyglass. The tunnel effect isolates value areas—and you can compare one to the other more objectively. You're not distracted by subject matter. Another useful exercise is to paint a scene with the correct values—but change all the colors. If a tree is green, paint it blue. If a sky is blue, paint it yellow. But keep the *same values!* Most students work in exactly the opposite way; they're so intent on matching the colors of nature, that they ignore values.

If you study nature, you find that values are never a haphazard affair. So don't guess about them; analyze what you see. Look around and ask questions. *Why* is a thing as it is? Try to figure it out. Discover the reason behind an effect—and you won't need the teacher. You can solve your own problems.

Figure 46A

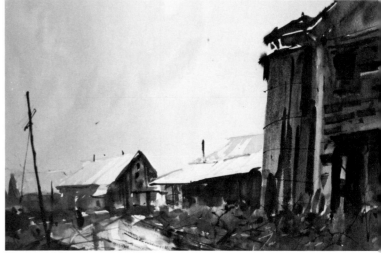

Figure 46B **Figure 46C**

Yet another exercise in value relationships is to take one of your pictures, keep the composition, but vary the areas of value.

Figure 46A, for example, was painted on-the-spot in Ohio. I liked the back-lit barns: the dark planes of the earth and buildings make a dramatic silhouette against the light sky. In Figure 46B, I converted this scene into a front-lit snow picture—simply by manipulating my values. Now the snow-covered foreground is the lightest element in the picture. The sky is still light in relation to the buildings—but it's dark compared to the snow. In Figure 46C, I made the subject into a rainy-day picture. The ground is wet and light; it reflects the light sky overhead and outside the picture. The rooftops of the barn catch some of this diffused light, reflect it, and are also light in value. The building remains dark, but the sky becomes much darker. By lightening the sky towards the top I suggest the source of the diffused light.

Color

When I was a student, I found color confusing. I was taught to take a "scientific" view of it. We looked at prisms, mixed colored light, manipulated the color wheel, and arrived at all sorts of mechanical rules, none of which had much to do with painting. I've since discovered that color is a fairly simple subject—if you think of it in simple terms.

Color has four basic qualities:
1. Every color has a *hue*; red, yellow, blue, etc.
2. Every color has a *value*; its light or dark.
3. Every color has an *intensity*; it's bright or dull.
4. Every color has a *temperature*; warm or cool.

Remember these four qualities, and you'll begin to understand color.

Warm and Cool

One of the most important qualities of a color for the painter is its temperature; warm

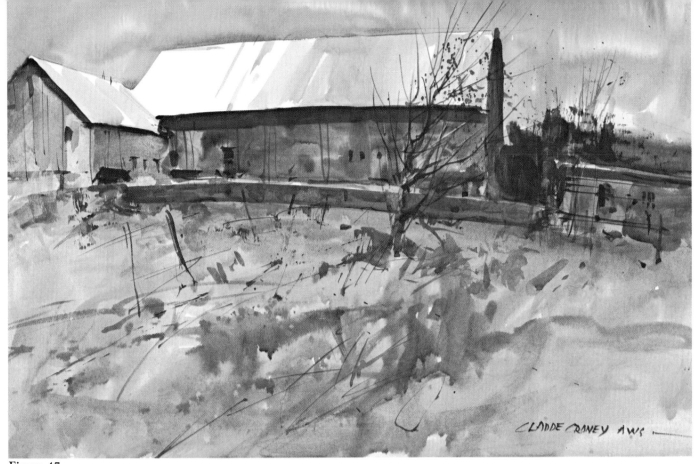

Figure 47
In this painting, done with only two colors, I make brush strokes suggest the planes of the objects. The strokes on the roof go one way; while those of the walls and land move in vertical and horizontal directions.

and cool help create color harmony, space and a feeling of light in a painting. Blue, green, and purple are cool colors, while red, yellow and orange are warm. I search for the warm and cool in everything. There may be some pure neutrals in nature, but they're rare. Of course, all things are relative—when compared to each other you can have a relatively cool red or a rather warm blue.

Nature is primarily composed of warm and cool color, intermixed. Warm and cool vibrate everywhere: outside, inside, upstairs and down. A blue sky, for example, is never pure blue. There's a little yellow ochre in it, or a touch of orange, or perhaps some burnt sienna. There is usually something to suggest the warming effect of the sun. A pure blue sky would be an isolated note in the picture; it wouldn't have any family relationship to the rest of the landscape. By mixing warm and cool, you're not only true to nature, but you also create color harmony

and visual interest. In fact, you could use *any* colors you want in a picture, so long as you intermix them, thus relating one to the other.

A Color Exercise

Figure 47 is an example of a picture painted with but 2 colors, one warm and one cool. Students should try working in this way. Working with only 2 colors they stop worrying about the teacher's "secret" color recipes. They're forced to think in terms of temperature and value. It's as if you lost one of your senses. When you can't see, for example, your hearing becomes keener. With a limited range of color you soon learn to get the most from them.

I don't care which 2 colors are used; but one must be warm and the other cool. And one of them should also be dark. You can't do much with cadmium red light and cerulean blue, for example; mix them at full intensity,

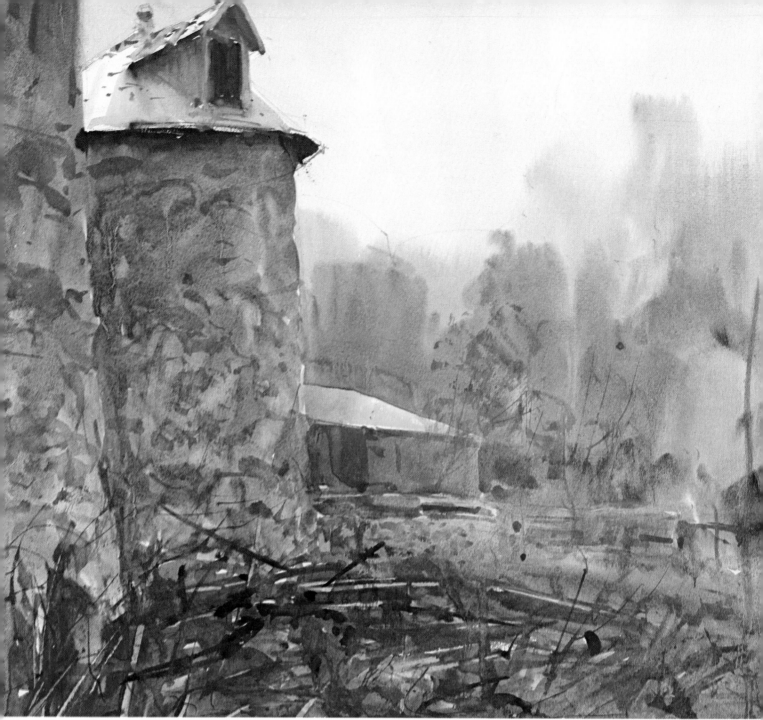

Figure 48
On a gray day, atmosphere exaggerates distances. I painted much of the background while the paper was damp, thus creating many soft edges. The hard edges and more pronounced textures are all in the foreground.

and you'll never get darker than a middle tone. Ultramarine blue and burnt sienna, on the other hand, are a good combination—as are Payne's gray and yellow ochre. In Figure 47, I used these last two colors, leaning the mixture one way or the other, depending on the warmth or coldness of the subject. With these two pigments there are at least 20 different mixes. Notice, for example, how warm and cool interact in the grass, the roof and the sky.

This exercise should also prove that it's not very helpful to know what colors a painter used in a mixture. It's not *what* you mix but *how* you mix it. Students trying to emulate me by making a sky with yellow ochre and Payne's gray can end up with completely different mixes.

Seeing Color

Remember color is always relative. As with value, students have trouble seeing color because of what they "know" about objects. They "know" that trees are green and the sky is blue—and so paint them a flat color. Often a distant green tree does not look green. It surely fades when compared to a green in the foreground or to a green on your palette. In Nova Scotia, the natives often paint their houses a blue that knocks your eye out. I tell students to study those houses—and *then* look at the sky. Compared to them, a "blue" sky doesn't look very blue at all.

In the same way, students think gray days are dull and cool, use lots of Payne's gray in their mixes, and end up with colors—green especially—that are too cold and acidic. If you really *look* at a gray day, you find it has lots of warm color: burnt sienna, burnt umber, and yellow ochre. Figure 48 was painted on such a day in New York State. You can see how the heavy atmosphere blurs and cools the distance. Yet notice the warm red under the silo roof. I felt this warmth at the site—and exaggerated it, knowing that warm, advancing colors in the foreground would emphasize the cool, receding colors of the background. The contrasting gray-green stones of the silo make the reds look even warmer.

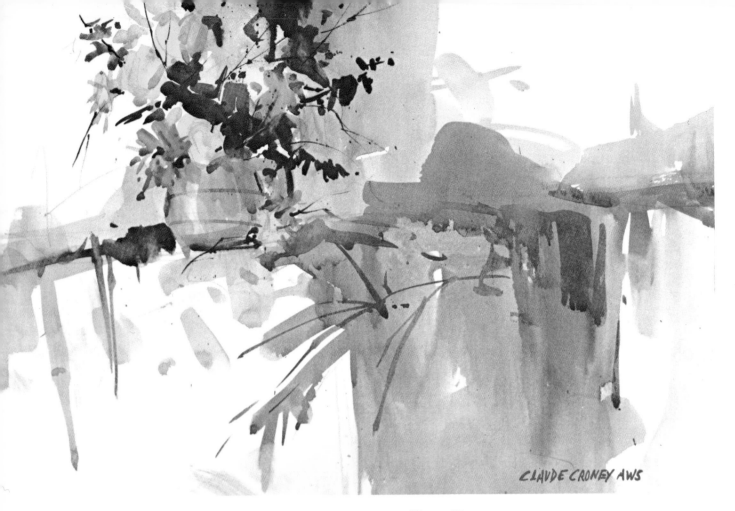

Figure 49
I like this flower arrangement because it's not too pretty or formal. The painting suggests the feeling of flowers—without my drawing each petal and stamen. It's just paint, but a sense of reality is created by the right value and the right shape.

Complements

Red and green form a complementary relationship. These complements are based on the contrast between warm and cool: yellow (warm) is the complement of purple (cool); red (warm), of green (cool); orange (warm), of blue (cool). And *vice versa*. Complements act in interesting ways; they tend to generate one another. I first noticed this when I was in high school. If an orange object was in front of the blackboard, the board—a neutral gray in itself—always began to look a little blue. A red object made it look greenish. The blackboard didn't change. My eye was reacting to the colors.

Knowing how complements work can help you see color better outdoors, particularly when you're confronted by areas that at first glance appear neutral and colorless. First ask yourself what colors are around these "dull" spots. A "gray" area of sky, for example, surrounded by green foliage will look reddish. The color difference may be subtle, but it will be there. Since colors are like people—they love complements—you could purposely introduce them to create an exciting color harmony.

In Figure 49, for example, the yellow flowers look good against a lavender back-

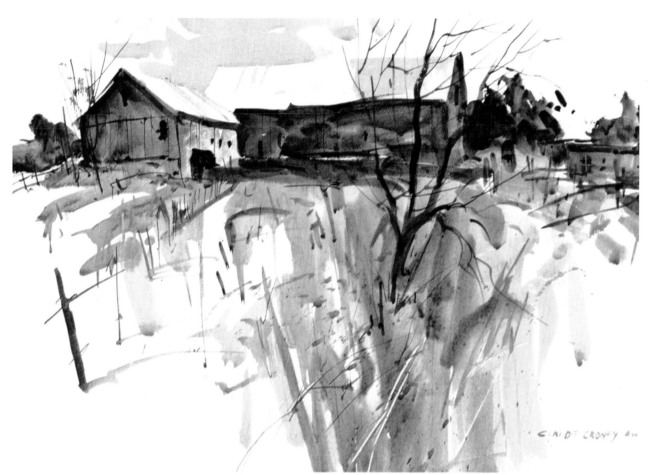

Figure 50
This is the same site as Figure 47. Here, however, I was struck by the grasses in the foreground and indicated them with quick, broad, vertical strokes.

ground. Yet this background isn't as intense as the yellow flowers; it's grayed so it won't compete. This fact brings us to another characteristic of the complements: side-by-side they emphasize each other; mixed, they neutralize one another. Here, the lavender was grayed with a touch of yellow. Notice that by graying the background in this way, we're intermixing warm and cool and thus giving the background a family relationship to the dominant yellow flowers. In a similar way, I've used green to set off the single red flower in the bouquet. In fact, if you study the picture, you'll see how each

area contains a hint of colors from all the other areas. These hints create color harmony.

Change of Color

Whenever you have big areas of color like those in Figure 49 it's wise to vary them. Of course, you often find objects that lack variety: a newly-painted red barn, for example. But even when confronted by such a subject, notice how I purposely introduce some changes of color. In Figure 50, I've used the fact that red likes green to give variety to my large barn.

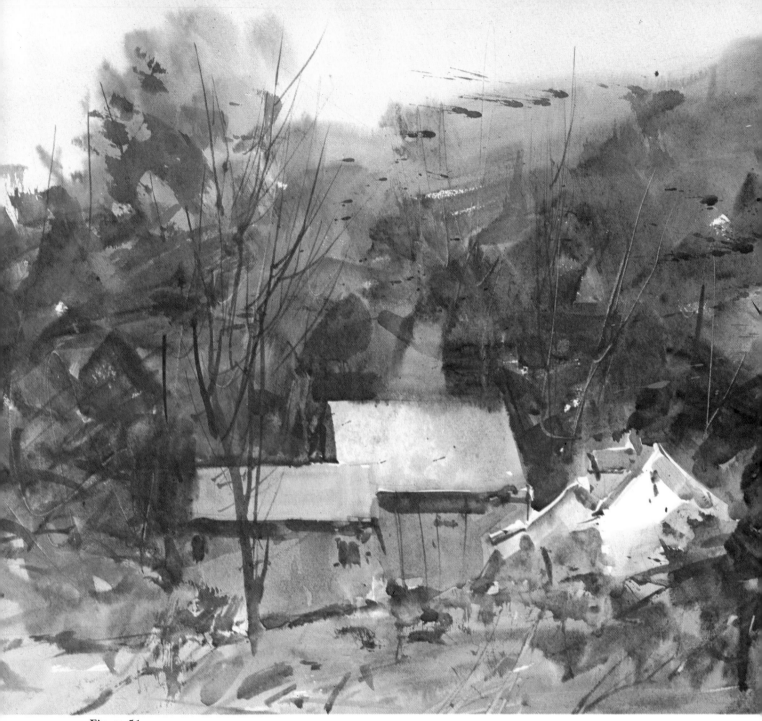

Figure 51
*I lowered the value of the sky to emphasize the white house. By
painting the background trees in a mass, I avoided a spotty look.*

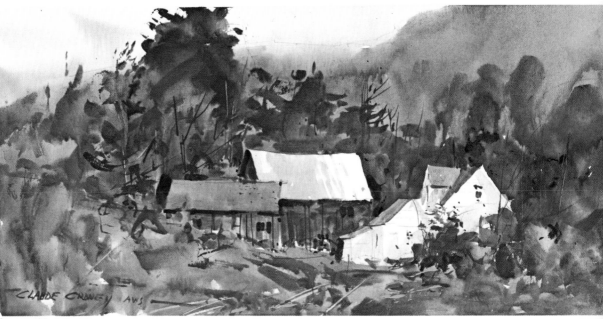

Figure 52
I like the way these buildings form a single, unified cluster. The largest area of white paper is reserved for the house, so it clearly stands as the center of interest.

Mood

By varying values and the intensity of your color, you can create different moods. As an example, compare Figure 51 to Figure 52. In each, both the scene and the lighting are the same. But the moods are different. Figure 51 suggests a happy, bright mood: the colors are intense and warm, with just enough value contrast to give the picture snap. Figure 52 is in a more sober mood: there is less value contrast and the colors are grayer. And by comparison, the picture is cooler in character. The subject remains the same: a farm among trees. Color and value create the mood.

A Warning

Although the warm-cool relationship can be used to darken and neutralize colors, it's not a rule. I tell you about it so you'll think in terms of color harmony. But it isn't always the best way of handling color. Some students, for example, darken a warm yellow by adding the relatively cool Payne's gray. That does the trick, but it also changes the yellow's nature. A warm color is often better darkened by another warm color. Here, burnt umber would be good, for it darkens yellow while keeping it warm. If you like, you can then add a cool color to the mix for variety. If you want to darken a light blue, on the other hand, the warm burnt umber might not be good; it could muddy the mix. You'd lose the quality of "blueness." In this case, the cool Payne's gray might be an appropriate neutralizer. When you paint, you always have alternatives.

If you'd like to experiment further with color, try the following exercise. It's a project we assigned students when I worked for the Famous Artists School. It starts with three squares, each of which is divided into thirds. In the first square, we asked the students to make each third a different *color* and a different *value*. In the second square, the students used the same colors—but made them all the *same* value. And in the third square, they picked one color to keep at maximum intensity, while graying the others. Yet, again, these grayed colors had to be the *same value* as the most intense one. Once you've run a number of variations on this exercise, you should have a pretty good understanding of value and intensity.

Of course, even when you understand these elements, you still have another problem to consider: the fact that there's a limit to what our palette can do. If you want to suggest a sunset, for example, you might do better to paint the reflection of the sun on an object rather than the sunset itself. The light from the sun is so intense that to get it on paper requires a compromise between value and intensity. The red in the sky at sunset is light in value. But if you paint it light, it may be too colorless. To get intensity, you have to make the color darker than it is in nature. That leads to another problem, since the sky is, after all, the source of light. You'd have to darken *all* the values in the scene so the red sky will—in relation—appear light. These are decisions each painter must make for himself. In some instances you may be willing to darken all the values. In others a value in nature may be so important—*as is*—that you won't want to tamper with it. Then again, you could split the difference, going neither too light nor to dark. Once you've learned to judge values accurately, this sort of juggling becomes easier.

In addition, our eyes not only see a much greater range of color and value than our palettes can match, but our tastes in color vary: some like red-hot colors and emphasize them, while others like ice-cold colors and exaggerate them. As a result, we can only hope to create the *illusion* of reality. We're lucky if we can work our limited range of colors and values into what, to the viewer, is a pleasing and convincing relationship.

4 Nature and the Studio

One thing we all learn quickly outdoors is that we can never find the perfect, "ready-made" subject. I've driven hours looking for them. And at the end of the search, I've been too tired to paint. We all want something that's so good we won't have to think while painting. There are few such ideal locations.

After I've demonstrated for a class, my students often complain that I picked the "best spot." Since I'm the teacher, I must know what's good. They feel there's nothing left to paint. But as we'll see in the following examples, it's possible to look at a single subject and come up with a variety of different ideas.

Drawing

Before we look at these examples, I want to talk a little about drawing. When you're at a site, it's hard to take that first step *away* from nature. As I've pointed out, nature is beautiful—but a painting is something else. We can't compete with nature. The scene is simply a source of raw material.

On the spot we're nervous. We're intimidated by what we see. That's why I recommend doing preliminary sketches before you start to paint. Once you've put a line on paper, you've taken away some of the shock of the scene. You've gone from nature to shapes. You begin to translate, to create, to interpret instead of simply rendering the subject "as is."

Figure 53

Choosing the subject

Many people have trouble determining a theme for their pictures. They do panoramas; that's the easy way to avoid making decisions. Yet the success of most paintings depends on how the artist edits and selects from what he sees. Students think the professional painter draws by starting and ending in just the right place—without making any mistakes in between. That's hardly the case. It takes *time* to figure out a composition.

I draw to decide what interests me at a site. The preliminary sketch is the germ of the idea. It helps me decide whether or not the subject has a chance. I usually walk around the spot, taking my time and trying to see what the subject is doing. If it's a building, for example, how long or short is it, and how do the different parts come together? Is the roof light or dark? How is it related to the sky or the background? If I look hard enough, I can usually find interesting shapes to work with.

Wait for things to look "right." I squint and step back and forth, trying to feel the mood of the subject. If there's a house and a tree for example, I move until they form an interesting, unified pattern. Then I get my notebook and begin my preliminary sketches. These usually average 2 × 3 inches and have no detail (Figure 53). There's no point in doing big sketches on a large pad. You do too much drawing that way. Instead, I may do 5 or 6 sketches in as many minutes. I quickly see what won't work and then move on to another idea. Sometimes I draw a square on the page—about the propor-

tions of the watercolor paper—and draw inside it. When I'm less sure of what I want to do, I draw freely and then panel off a promising area. I look for value patterns and interesting shapes. I draw with a pentel, a magic marker, or a 4-B pencil. If I get the design to work on a small scale, it has possibilities.

Looking at these sketches, nobody but myself would be able to understand them. I use my own special shorthand. I showed a class my notebook one day and suggested they try making similar sketches themselves. The loose character of one man's studies particularly impressed me. Looking around the site, I asked him what he was drawing. He told me he didn't realize he was supposed to have a *subject*—he was just trying to imitate my scribbles!

The Drawing Habit

Some people hate to draw. They think drawing keeps them from being "creative" and "free." I feel that a little structure never hurts. After all, many "free" pictures can also be very shallow. They lack a solid sense of construction. At times a picture turns out well; sometimes it doesn't. Painting often becomes a matter of lucky accidents—of hit-or-miss.

When I was a kid, I worked fast, without giving much thought to preliminaries. My teacher liked my technique, but he'd always say, "you still have to *draw* it, boy!" Now I spend more time finding the right shape and placing it properly on the paper. In fact, I tell students to get into the habit of drawing. We have eating habits and exercise habits, so why not a few good habits in art? If a subject is worth painting, it's worth planning and drawing.

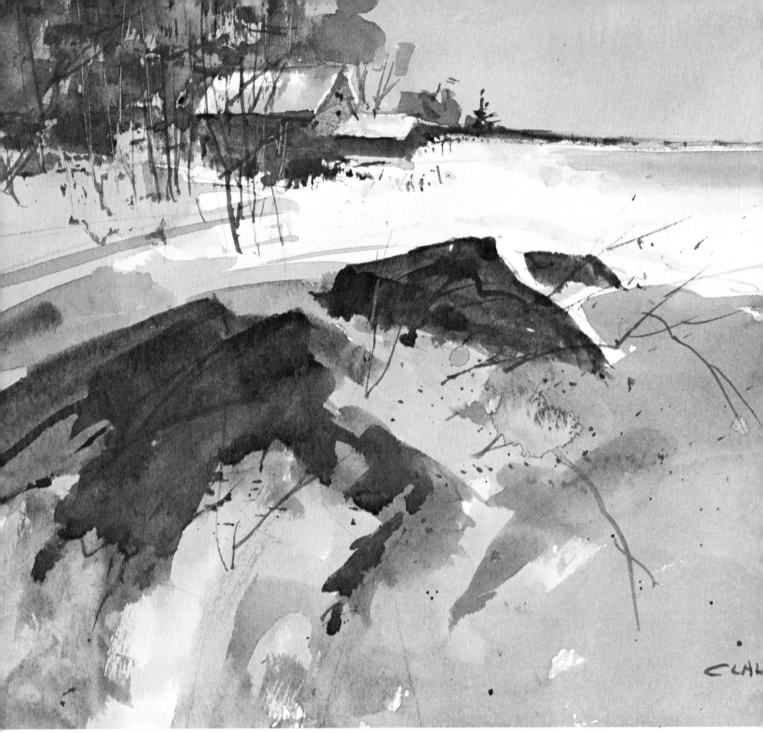

Figure 54

70

CRANEY AWS —

I don't want to solve compositional problems on the watercolor paper. My main thinking is done in the sketch book. I do my *completing* on the paper. The character of the drawing on the watercolor paper is especially important. A tighter, more exact drawing allows you to paint more freely. I use a ruler and will draw as carefully as time allows. When you draw *and* paint loosely, there's always the danger your painting will fall apart. I draw slowly, establishing proportions and placing the masses properly. My final drawing is sparse. It's a guide, and I don't adhere to it rigidly. But I may spend half the time at the site getting it right. I labor at the beginning so I can avoid labor in the final picture. It's frustrating to have a picture practically done—only to discover there's a problem that a little careful preliminary drawing might have solved.

Figure 55
The first sketch. The masses are too balanced.

Figure 56
The shapes are more interesting here, but the picture still seems crowded.

Figure 57
By increasing the size of the door, I add openness and freedom to the design. I also eliminate the area of wall on the right—a mass which might detract from the light in the window.

Decision-making

Figures 55 through 57 are the sort of quick sketches I do to establish the design for Figure 58. I've moved close to the subject; and the closer you get to objects, the more abstract they usually become. You've probably noticed this in prize-winning photos; when you see close-up studies of rocks and leaves, at first glance it is difficult to identify what you're looking at.

The first sketch (Figure 55) shows the scene as it was; an open doorway framing the dark

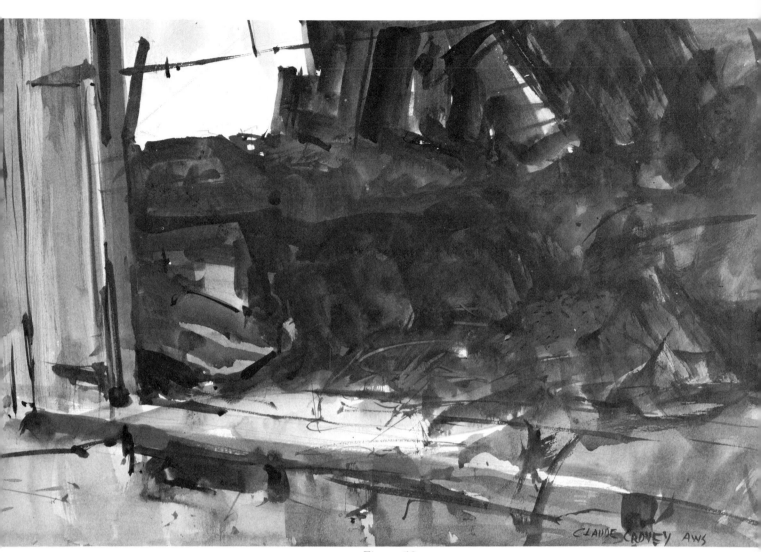

Figure 58
By carefully controlling the values the foreground threshold is kept light, but it's not as bright as the light coming through the window.

interior of a barn. The design looked too balanced and confined. In Figure 56, I made these shapes more irregular and added diagonal lines to give movement to the scene. The design was still static—so in the last sketch, Figure 57, I eliminated the right side of the barn. The picture now has more air and a more active look. Figure 58, the final painting, has good shapes and seems unified in design. I don't worry about details. In fact, I can't remember what most of the stuff in the barn actually was. I'm

happy so long as I preserve the light and dark contrasts that originally caught my eye.

Figure 59 is the result of the same kind of thinking. A friend invited my class to his farm; and when we arrived, I was struck by some flowers on the porch. My first sketch, however, included lots of sky and building. The more I drew, the less important the sky and barn became. Finally, I stopped and asked myself "what do I *like* here?" The answer was easy: the flowers and the porch. So that's what I painted.

73

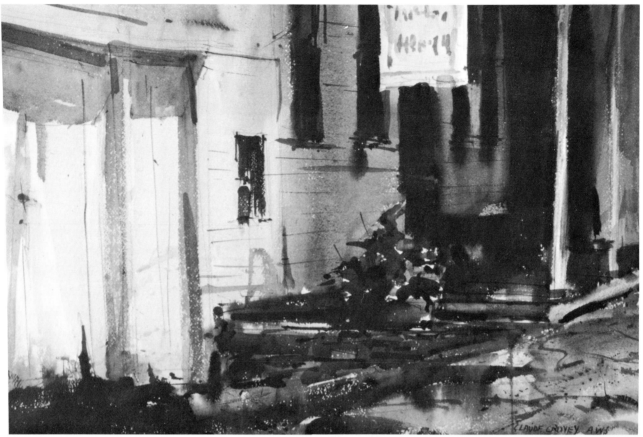

Figure 59
The shadows in this picture are arranged so the building doesn't break into two equal, light and dark segments. The sign and light porch supports add interest to the shadow part of the picture. Dark shadows and a window break the sunlit area.

Figure 60

On location with my class in Vermont. This is one of my favorite subjects. You can see other versions of it in Figures 47 and 50.

The Barn

In Figure 60, you can see my class at a spot in Vermont. A friend once said to me that "you do barns." And after I thought about it, I guess I do paint a lot of them. I do them because they're around me, and I find them more interesting, as shapes, than split-level houses.

Figure 61 is a fairly literal view of the scene. I included the large expanse of light roof, but varied the value in order to make it more interesting. I removed the leaves from the tree, visible in Figure 60, so it has a less balloon-like shape. I also moved the tree to the right, so it no longer cuts the barn into two equal, monotonous and distracting halves. The tree now has

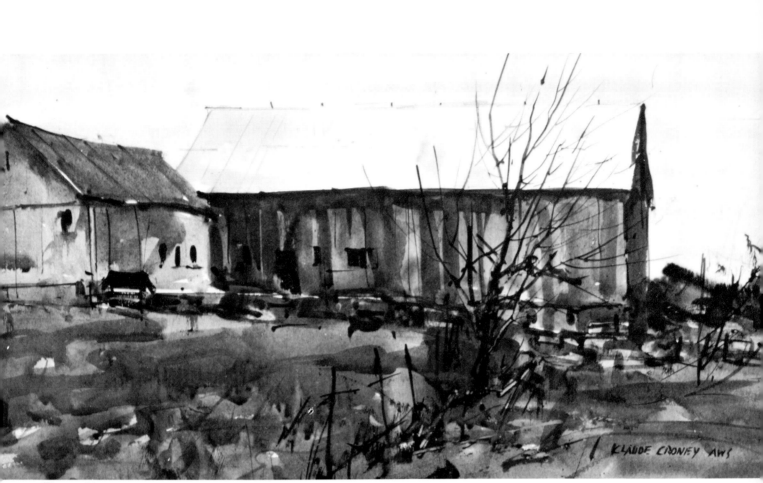

Figure 61
I moved the small tree because it was cutting the barn in half. When it was moved, however, I had to avoid placing it in the middle of something else. It's easy to miss one trap—only to fall into another.

a number of compositional functions:
1 The branches break up the large roof and create an entertaining pattern.
2 The tree adds a strong vertical element, relieving the dominant horizontal movement of the picture.
3 The branches help obscure the right side of the barn and force the eye to concentrate on the left-hand part. I also lighten the right end of the barn, so the lines of the dark trunk and branches can be seen against it.

In the Studio

Back in the studio, I sort out the facts gathered on the spot and decide to develop the basic barn idea into a series of snow scenes. I use high and low horizons and vary the lighting to create different value patterns. Having worked outdoors a lot, I know how light behaves. I try to get a feeling of truth in these studio pieces. But it's important to have the outdoor experience first. I think of the outdoor sketches as raw material and use them to set the studio pictures in motion.

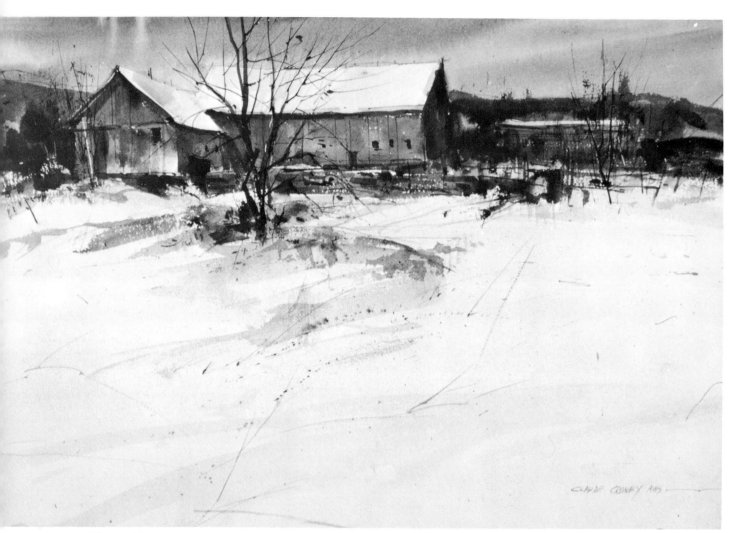

Figure 62

Front Lighting

Snow scenes are usually front-lit; in Figure 62, the sunlit snow is suggested by the white paper. Even on a light, gray, overcast day, the sky will be slightly darker than the snow. In this picture, I dramatize the effect a bit, making the sky even darker so the snow will look more brilliant. The tree to the left, is used to emphasize the lacy pattern made by the branches against the sky and roof. The large, relatively empty foreground is made interesting by a little spattering. Just enough technique is used to show something is happening—a little dry brush, a few washes, some suggestion of grass pushing up through the snow. They add interest—without taking the emphasis from the barn.

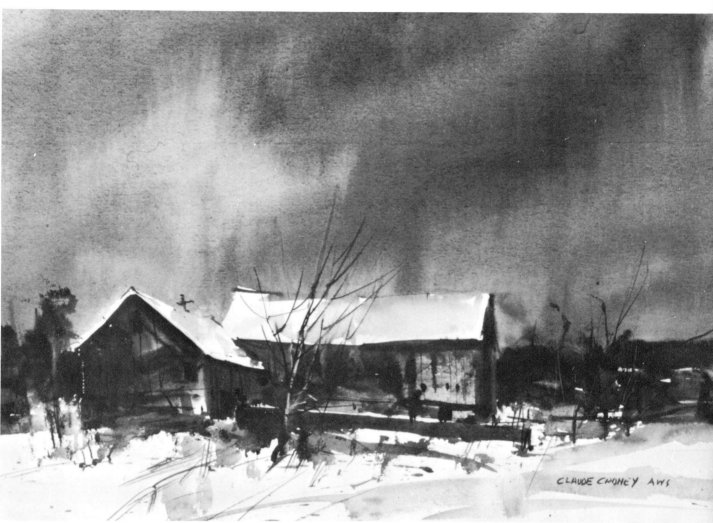

Figure 63
*Variations in value add interest to the sides of the barn. The dark
sky and background emphasize the whiteness of the snow.*

Low Horizon

In Figure 63, I again use front lighting, but
lower the horizon and make the sky more dra-
matic. There's less white in this picture than in
the previous examples, and I want it to register
forcefully. The paper can't be made any whiter,
so I make it look brighter by placing strong
darks around it. Interest is added to the barn
by varying the values and color of its sides.

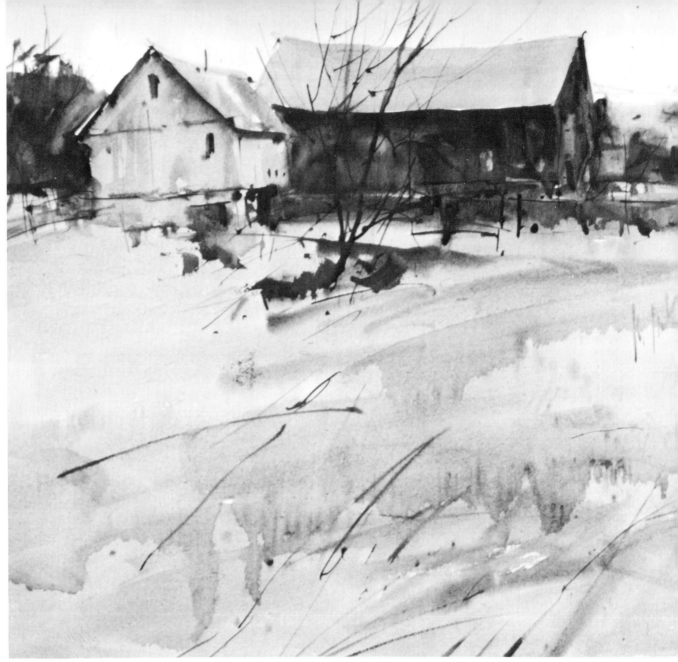

Figure 64
The sun, hidden behind the barn, affects the color and value of the background. You can see how it "eats" away at the edge of the trees as they show against the sky.

CLAUDE CRONEY AWS

Back Lighting

Figure 64 is an exercise in value relationships. We're looking towards the sun at twilight, with the sun behind the buildings. In contrast to the two previous illustrations, the snow is now *darker* than the sky. In fact, the only unpainted bit of paper in the picture is at the horizon. Even the white part of the barn is dark; as a vertical plane, it catches less light from the sky and is a little darker than the horizontal mass of snow.

Blurred edges, drips and line work are used to suggest texture and the undulations in the surface of the snow. The foreground shouldn't look like a billiard table. The area is simple—but not so simple that it looks unfinished. It's interesting, but it doesn't detract from the subject.

Figures 65-68
I took these photos without trying to "compose" them. They were designed simply as a source of raw material.

The Camera

I've always warned students about copying a photograph. It may be useful practice for drawing and matching values. But it doesn't sharpen their compositional skills. When you copy photos you tend not to use the material. Instead of you being in control, the photographer takes over.

I had my camera when I visited the spot illustrated in Figures 65 through 68. But instead of taking a single photo, I took a number of detailed shots. That way I had plenty of material; I wasn't as limited as I'd be with only one picture to work with. Besides, I wasn't sure what I wanted to do. I was just curious about the spot.

Using these photos in the studio, I developed a small pencil sketch (Figure 69). I tried to figure out where to put the building on the paper. I used a squarish format, a shape that tends to have an almost equal force in both the horizontal and vertical directions. I don't really like such shapes; they're too balanced. Elongated shapes appeal to me more. They already have a principal movement, and you only need a small, opposing force to balance them.

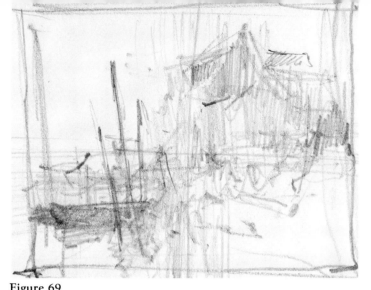

Figure 69
As usual, I approach the painting by first doing a rough preliminary study.

Figure 70
The height of the building and pilings is exaggerated in order to get movement into relatively static shapes.

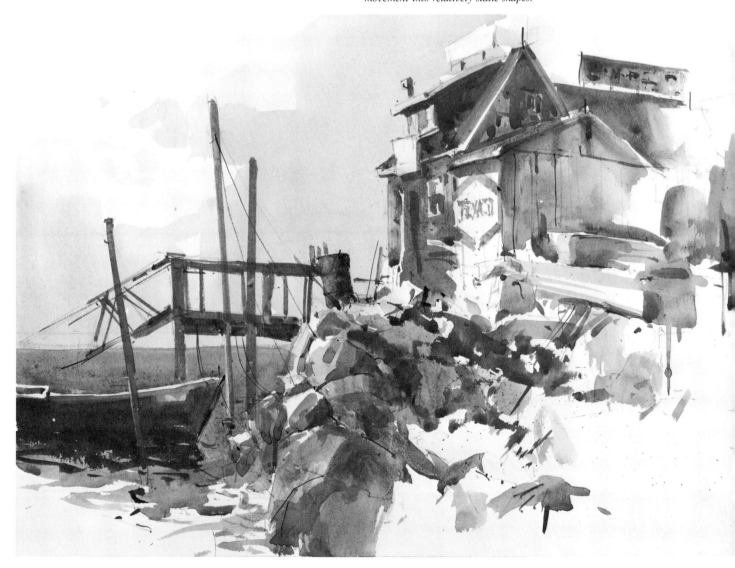

In Figure 69, you can see that I decided to place the building in the upper right. That gives me plenty of room for varied secondary shapes. If the building were lower, I'd have too much sky—and the sky doesn't interest me here. If it were more to the left, I'd have shown all the trucks and other gear. They don't interest me either. The placement is dictated by my answer to the question: What do I like?

In the final painting, Figure 70, I eliminated the distant retaining wall. It was a confusing shape and added nothing to what I was trying to say. I made the shadow side of the building into a simple mass. Again, it's too confusing in the photo. The lettering on the sign is the sort of detail that I do late in the painting process. If I did it early, I'd have a hard time deciding how dark it should be. The letters might look snappy against white paper—but light, once I place my halftones.

Conclusion

There was a time when I was a "purist" and believed you should only work outdoors. I still do much of my work on the spot, but I also know that the field and the studio can complement one another. Indoors, I can be more creative; and that creativity spills over into my work on the spot. Without it, my outdoor work would be too literal. I'd be reluctant to make changes. Studio work gives me courage to take a chance.

5 Vignettes

Vignettes are a specialized area of composition. They're interesting because they use—in an exaggerated way—most of the design points we discussed earlier. When you do a vignette, you have to ask the critical question: what should I leave out? You not only paint what you see; you have to *see* what you paint. And it actually takes longer to see what you paint than it does to paint what you see. Creativity lies in this step. The vignette forces you to make shapes. You have to create the design. You have to take liberties with your material.

Severe editing is the key to the vignette. In the commercial world, there are certain "rules" governing their construction. I could never remember them—and so made up my own. Peter Helck got me started when he challenged all of the instructors at the Famous Artists School to do a painting with an old car as a theme. As I developed my picture, I sensed I should treat the subject as a "reminiscence." We usually recall the past in bits and pieces, so a vignette seemed the natural solution to the problem. That was my first vignette. I've done many since.

In a vignette, as in all good pictures, you have a center of interest balanced by subsidiary areas. Together they form a single positive shape, which usually touches *all borders* of the paper. One problem with the vignette is that if you have too much white space, the unpainted area may overpower the subject, making it appear to float on the paper. If you have too little white space, you no longer have a vignette. It's also easy to let the subject get so big that there's no room left for the secondary material.

Edges are another problem. They must be handled with care. If they're all hard, the vignetted area looks as if it were precut and stuck on the paper. As in all good pictures, some edges should be soft, some hard and some broken. That helps unify the painted and unpainted areas. They overlap each other and thus work together.

Figure 71

Practical examples

Probably the best way to explain the vignette is to look at a number of examples. Then we can discuss why each was done in a particular way. When you do vignettes, it's easy to repeat similar compositions—especially if you go out planning to paint a vignette. I seldom expect to do a vignette. It all depends on how the subject strikes me.

When, for example, I arrived at the site shown in Figure 71, I had trouble getting interested in the scene. The buildings and much of the surroundings bored me. It seemed best to leave such things out—a natural for a vignetted composition.

As you can see in Figure 72, I dropped the distant houses and reduced the height of the background trees. I also darkened these trees, since I needed a contrasting value to emphasize the light boats and pilings. The "truth" wasn't helping me make my statement. I put some boats in the distance; they add sparkle and show the viewer he's looking at water. The latter is a flat wash, with a few strokes to suggest ripples. I didn't bother with the seaweed on the shore. Who really cares about it? Textures suggest the character of the subject. Notice, for example, how I used spatter to indicate the stones on the beach.

Looking at this vignette, you can see how the shape is reminiscent of a cross. But it doesn't have a cross's monotonous, mechanical regularity. The contour varies. And I use lots of different edges. Notice the line of the distant trees against the sky. The edge is hard on the right near the frame; it softens, hardens, blurs into the sky and pilings, then hardens again. These shifts help tie the vignette together.

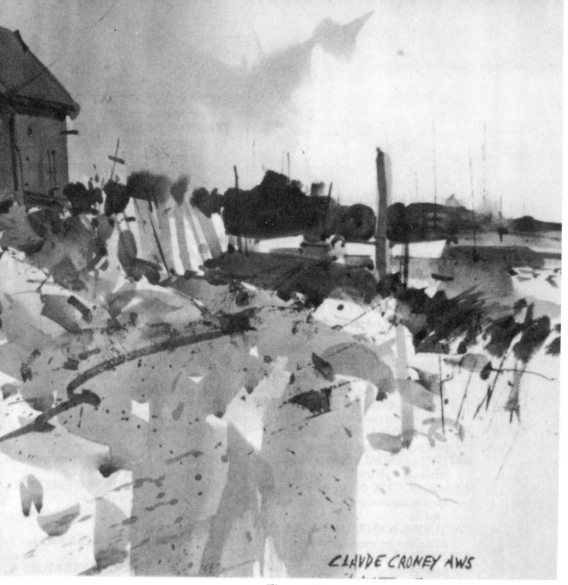

Figure 72

Toward the end of painting this picture, I added color interest by using a couple of touches of brilliant red. The rest of the picture is subdued in tone. The sky at the site was a bright blue, but I felt a quiet lavender worked better with the dominant gray-greens of the landscape.

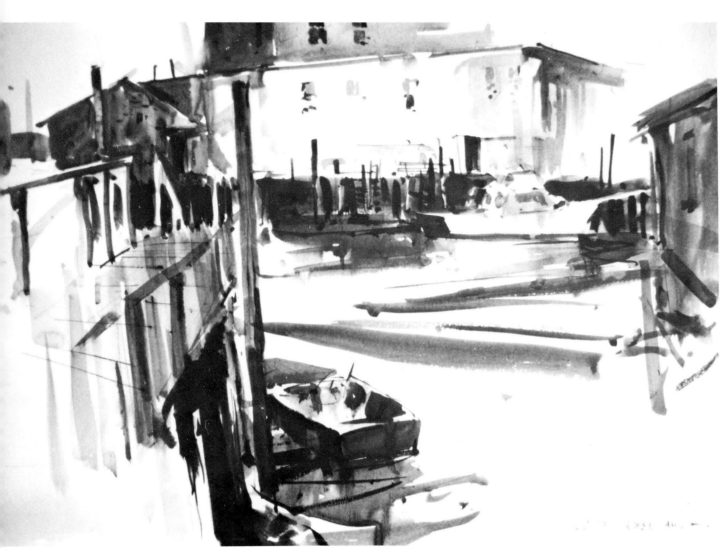

Figure 73
Students often wonder how to paint things as confusing as harbor pilings and wharves. Just ask yourself, what's the shape of an object? What's its value? Its texture? What's the character of the edge? And what is the value of areas around it? Once these questions are answered, you'll be able to paint the most complex subject.

Figure 73 looks even less like a cross. Here I was confronted by a different problem. The scene was *too* interesting. Wharves and boats criss-crossed the foreground in a way that created a jumble of awkwardly-shaped pieces. Everything was locked tightly together. I used the white spaces as a way to get the viewer in and out of the picture; they add a note of freedom.

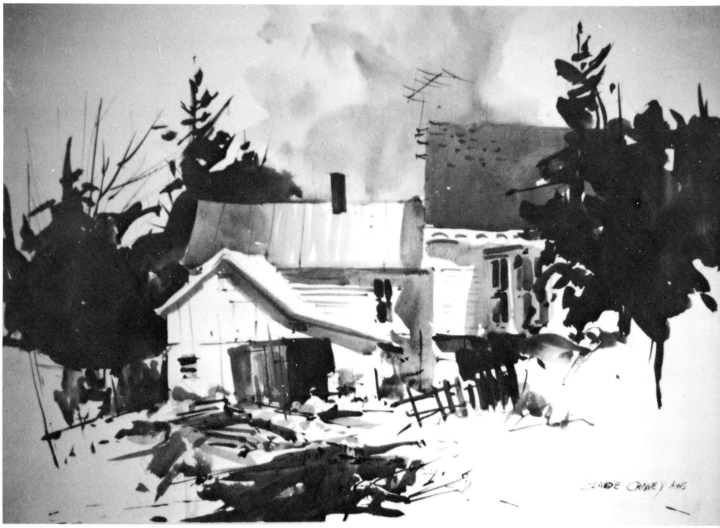

Figure 74
Hard edges and value contrasts attract your eye to the door of the barn. The warm colors of the clothes on the clothesline also pull you towards the left-hand side of the picture.

In the last 7 years I've probably painted at the site of Figure 74 at least half a dozen times. I always tried to do the whole scene, and was never satisfied. One day I was struck by the open barn door and the clothes on the line. I chose to play down the bay window on the right and decided a vignette was my logical form. The roofs were all light at the scene, but I purposely added graduations in value. They make the vignetted piece more interesting. It's not white-on-white. The trick in a vignette is to omit things in as *interesting* a way as possible.

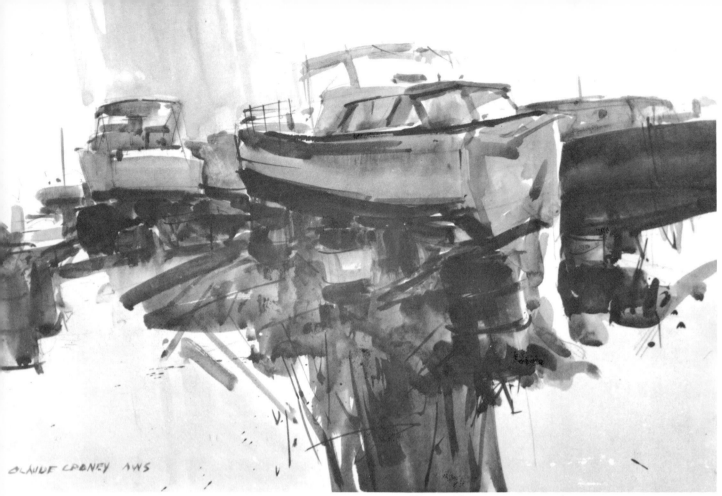

OLIVOE CRONEY AWS

Figure 75
You can see how this vignette has a great variety of shapes. They're unified by a closeness of value and by my use of edges. Notice how often one object blends into another.

Standing at the marina in Figure 75, I was surrounded by wall-to-wall boats, all looking the same size and shape. Had I painted them "as is," I'd have had a series of boring horizontal bands: grass, boats and sky. So I decided to focus on a few boats, emphasizing the one in the foreground. This was a tricky theme for a vignette, since it includes white boats, back-lit. I finally used five boats, all of different sizes and shapes. I then selected those oil cans, bits of grass, and pieces of wood that could be used to form interesting shapes. The tarpaulin on the bow of the nearest boat was especially important. If I'd shown the bow, it would have pointed too forcefully out of the picture. The tarpaulin is a vertical shape; it breaks the horizontal movement and helps hold the eye in the picture.

Figure 76
Although there are a number of individual buildings along this street, the soft edges help to unify them; usually each building is tied into the ones near it.

My painting workshops take me to many parts of the country. In the following illustrations you'll see how I use the vignette to interpret a small town in New England and a city in the Middle West.

I painted Figure 76 on my first day in Wilmington, Vermont. When I arrived at the spot, I wasn't thinking in terms of a vignette. I was immediately impressed by the shapes of the buildings. But, as in some of the previous examples, I also felt there was too much; if I put it all in, the picture would have become too "pretty." The minute I feel this lack of interest, I know I want to do a vignette. Because I plan to include less, that doesn't mean the drawing is any easier. Here I spent a half-hour getting the buildings and architecture right—about as much time as I took to paint the picture.

Figure 77

I use horizontal slashes—water—to break the square shape under the bridge. I wanted to include the window in the upper right of the picture. It emphasizes the nearness of the building. But I kept it dark, so it wouldn't attract attention to itself.

CLAUDE CRONEY NWS

The left-hand side of the street was of interest, so I pushed it beyond the center of the paper. It dominates the composition. The grill work, the porches, the white fence and the telephone poles were also nice. These elements not only added to the feeling of the city, they also cut across the background trees, breaking what might otherwise have been an excessively sharp downward movement. The cars on the right help lead the viewer into the picture. They also add life to the scene. At the site, the cars didn't overlap one another. I pulled them together, unifying them and—because one is clearly *behind* the other—adding to the pictorial depth. I don't bother with the wheels. I just want to get good, interlocking shapes. Their small size keeps them in a subordinate role. Notice, also, how the cars are blurred and the edges broken helping to make them a part of the surroundings. They seem to fit with the rest of the composition.

The vignette adds zest to a subject because it plays up the "good"—and lets you replace the "bad" with interesting bits of white paper. In Figure 77, I didn't change things very much. But I left a lot out. This view of a bridge is only a few feet from the site of Figure 76. I especially liked the way the vertical movement of the church steeple contrasted to the dominant horizontal movement of the bridge. As I sketched, this steeple kept getting taller and taller. I was left with a choice: should I keep it in or let it go off the top of the paper? I decided to take advantage of it; I made it taller and thus more important. I felt differently about the bridge. Its horizontal movement was *too* powerful, so I introduced a downward stroke on the left to break the thrust. I didn't know I needed this stroke until I was well into the picture. That's the difference between painting what you see and seeing what you paint.

CLAUDE CRONEY AWS

When I arrived at this spot in Cincinnati, Figure 78, I knew immediately that I didn't want to paint the entire city. I was attracted by the distant steeple and the way the light caught a few nearby rooftops. There were more roofs all across the foreground. But they were monotonous. There were also some very interesting chimney pots nearby. But they were *too* picturesque. They made a picture in themselves. So I omitted them.

I decided to emphasize a sunlit roof that was actually far to my right; I pulled it towards the center of the composition. The complex shape above it is a modern condominium. I kept it in the picture because I needed a vertical to counteract the strong downward movement of the distant hills. This vertical not only gives the picture a lift; it also suggests the way the new and old mix in the city.

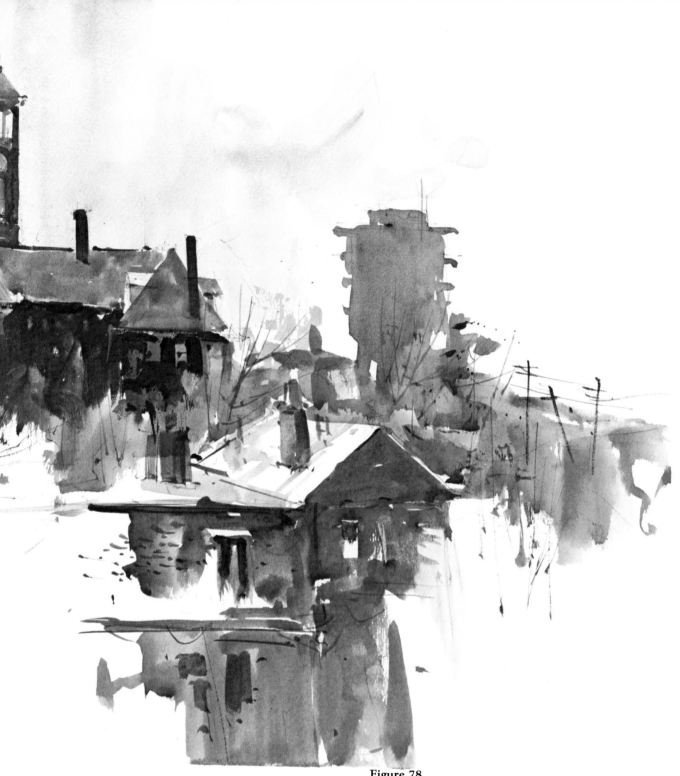

Figure 78
This composition steps slowly down from the upper left to the lower right. The movement is interrupted and balanced by the vertical trees, towers, chimneys, houses and telephone poles.

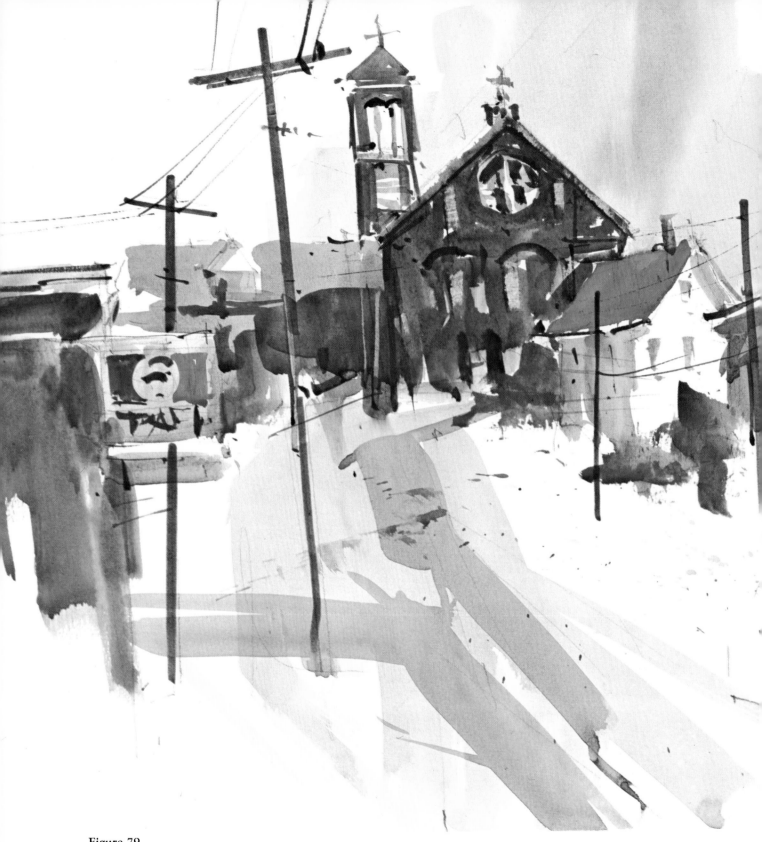

Figure 79
There is a dynamism always present when you stand in a city street.
Here I tried to suggest that excitement by sharp angles, diagonals,
and lots of broken, active shapes.

94

CLAUDE CRONEY AWS.

Figure 79 is a closer view of the church seen in the previous illustration. You can recognize the tower. I had to make a number of changes in the scene. The roof of the white house for example, was on a level with the roof of the church building behind it. The similar shapes were distracting. So I lowered the white house and reduced it in size. I added interest to the street by angling the houses and poles. The street was originally a simple, flat wash. But once I painted it, I felt it was blank and boring. It needed *weight* to balance the strong shapes of the buildings. I used some spatter to break up the space. But, more importantly, I added bold, angular brushstrokes. These strokes suggest the direction of the street, while they also lead the viewer towards my center of interest. The strokes are broken, too, and move in different directions. They were placed for *design* purposes. Not because I wanted the area to look more like a "road."

These two paintings show how the vignette shape can be used to express different moods. Figure 78 is a panorama; it's quiet and has lots of soft edges. Figure 79, on the other hand, is a closer view, with lots of active diagonals. To me, it even *sounds* noisier—like a city street— while Figure 78 is more tranquil.

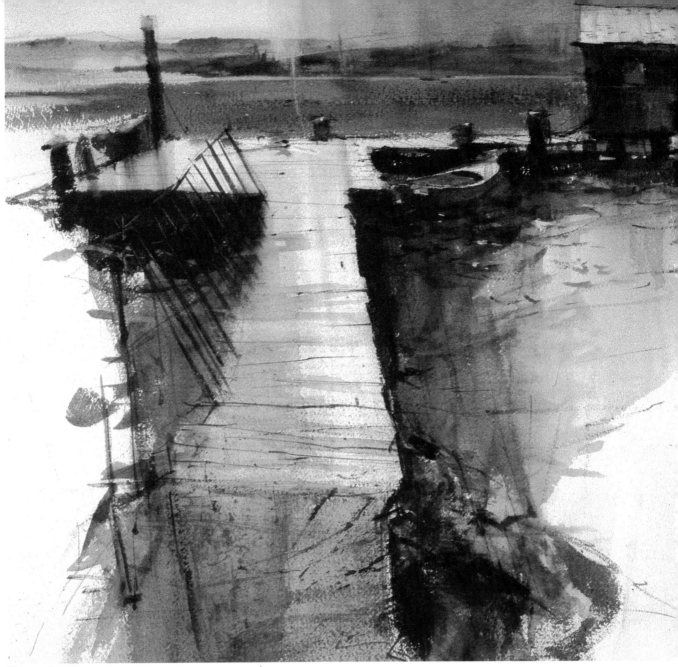

Figure 80
The distant building and small boat were used to balance the power-ful mass of the wharf. The textures of the wharf and nearby rocks add visual interest to the foreground.

The Float

I'll end this discussion of the vignette with one of my favorite examples of the form. When I arrived at the site of Figure 80, there were boats everywhere. A traditional handling of the scene would have resulted in another "pretty" picture. I walked around the spot and my eye was caught by the powerful thrust of the T-shaped float. I decided to emphasize it. To enhance the drama of the site, I used a lot of vertical strokes—even the reflections on the float are vertical. I countered this dominant thrust with both the horizontal marks in the water and the diagonal structure on the float nearest the viewer. Notice, however, that the water is hardly painted; that would have given it too much emphasis. The horizontal and ver-tical movements give the picture a sober, dignified feeling; a feeling that is further sug-gested by the use of low-key colors.

CLAUDE CRONEY A.W.S.

Summary

My way of looking at the vignette can be easily summarized:

1 The subject and the subsidiary areas should be *larger* than the unpainted area. You don't have to measure the spaces, but they should look right to you.

2 Usually I like a part of the vignette to touch each of the 4 borders of the picture.

3 The resulting corners—mostly white paper—should be different sizes and shapes, broken so they don't look like mechanical half-circles or triangles.

4 The vignette should contain a variety of hard, soft and broken edges. These edges relate the subject to the surrounding space and keep it from looking pasted on the paper.

When doing a vignette, each stroke must be related to the overall pattern of the picture. How dark should the stroke be? What direction should it take? Should it have a hard or soft edge? Each small shape must fit within the larger shape of the vignette itself. You can't think in bits and pieces. That's why the vignette is good for a student—even if he doesn't plan to use the form often. When he goes back to more traditional pictorial methods, he has a better awareness of the importance of pattern, shape and edge.

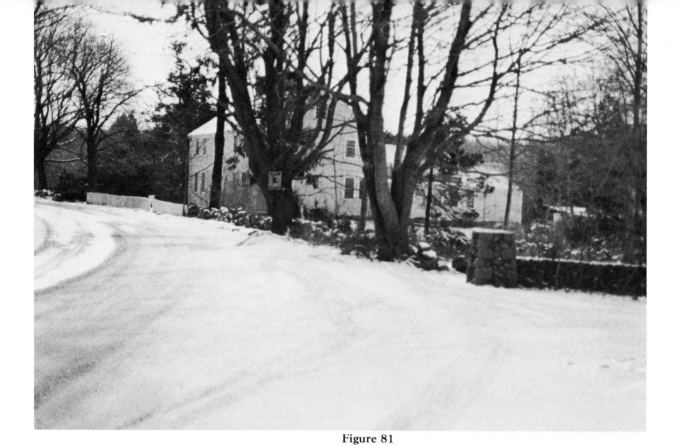

Figure 81
A photograph of a subject near my studio. Notice how neat and orderly it looks.

Figure 82
In the pencil study, I tried to subordinate the uninteresting expanse of foreground and to break the powerful leftward movement of the road.

Figure 83
This quick value study let me see if the picture had a pattern that worked. No matter how much detail I added to the final picture, I wanted to preserve the big pattern.

6 Demonstration

Now that we've talked about the way I think when I work, let's see how I actually go about painting a picture. Figure 81 is a photo of a spot down the street from my studio. As usual, I first think about the subject by doodling in my sketchbook. Even after years of painting, the initial planning of the picture is still a struggle for me. I need to warm up, to get involved, to figure out just what it is that catches my eye. In short, I have to decide which elements make the scene *personal*.

Figure 82 is my rough pencil sketch. I was struck by the fact that though the house is big, the trees are much larger. To emphasize their height, I've kept the horizon low. This decision also eliminates a lot of uninteresting foreground. I try to emphasize the *shape* of the house in my sketch. At the site, the architecture is obscured and confused by foliage. The building is placed off-center, adding a needed variety to the distances from the house to the picture border. The line of the stone wall is broken and I add some movement to the snow. Breaks in the snow now curve *towards* the house and trees. The trees are also pulled together, so they intertwine and form a single unit.

I'm doing this demonstration in the studio and have the luxury of plenty of time. As a result, I also do a small monochrome wash drawing, Figure 83, of the final composition. The sky is toned in order to emphasize the snow. Notice that the sky and snow are still light when compared to the darker trees.

Step 1

The sketch on the watercolor paper establishes my general proportions. I place the building and trees; but I don't draw each branch. A few key branches are suggested. I can *ad lib* the rest. Seeing the two trees as a unit, I exaggerate their height and make them dominate the picture space.

Once I've done the drawing, I don't feel a responsibility to follow the lines closely. If I do, the picture might look like something out of a coloring book. Coloring books teach us to be neat, and that training often gets in our way as painters. If the final picture has pencil lines that don't relate to the washes, that's all right with me. Such lines are part of the feeling and romance of the medium. They add to the *spirit* of the picture.

Step 2

I decide to use Fabriano 140 lb. cold press for the painting. Since it's a gray day, I'm using a limited palette of only 6 colors: yellow ochre, Payne's gray, burnt sienna, Hooker's green, cerulean blue and alizarin crimson. The sky is worked on first, since it helps set the mood.

Using the largest brush suitable for the area (a number 14 round sable), I apply a yellow ochre wash over the sky. To this I add, wet-in-wet, Payne's gray and burnt sienna. I start at the top of the paper and work down, painting right over the distant trees. I often work from top to bottom, since water naturally runs down into dry areas. Near the horizon, I add some alizarin crimson to the wash for variety.

This big wash is not a technical problem. It's all a matter of working quickly. The whole sky took little more than three or four minutes. It *is* hard, however, to get the right value for the sky, given all the distracting white paper near it. Yet the sky's being a little darker or lighter won't make too much difference here. The *trees* are my main area of interest.

It takes a lot of water—but not too much! Students often think they're having trouble with brushes and paints, when it's really *water* that's giving them problems. They use too much, the paper begins to buckle, they throw on more paint, and the whole thing becomes messy and muddy. So how wet should it be? When should you wet the paper? And where? Everything depends on how you feel about the subject. Sometimes I wet part of the paper; sometimes all of it; sometimes none of it. I use enough water for the job, but there's no way I can describe how the brush feels in my hand. You learn to sense the wetness of an area when you put brush to paper—not when you read or hear someone talk about it.

Watercolor can be deceptive, too. For example, it's an unwritten rule that if the value of a color looks right when you put it down,

the chances are it's probably wrong! The wetter the area, the lighter it dries and the softer its edges will be. If the paper is only damp, you can control edges better and drying will change the values less. When the paper is slightly damp, it's very compatible with the paint and the final edges will be even less soft.

Step 3

I used Hooker's green, alizarin crimson and a bit of burnt sienna for the trees along the horizon. By pushing my brush—a #8 round—sideways, a rough, dry brush effect is achieved. When blotted with tissue some of the edges of the trees blur. A #4 rigger was used to create the thin, lacy trunks and branches.

The house was left alone, because I'm still not sure what to do with it. What value should it be? How yellow do I want to make it? A yellow house can look very yellow on a gray day; but if I make it too strong, it won't be in harmony with the subdued color of the rest of the picture. I often leave such important areas for the end of the painting process. By starting with what I feel confident about, I avoid the danger of getting a key area wrong early in the work. This caution differs, however, from the natural timidity of many beginners. They work in the corners because they fear to venture onto the center of the paper. They're afraid of "spoiling" things—and they hope that if they stay away from trouble their weaknesses won't be noticed. Corners are usually places to avoid. They have an angular, distracting shape. They naturally point *out* of the picture. And if you put detail in them, you further take from your center of interest. I prefer to keep corners mysterious and a bit out of focus.

Step 2

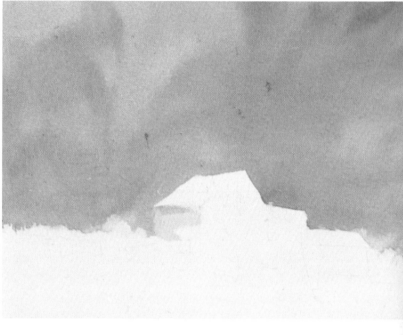

Step 3

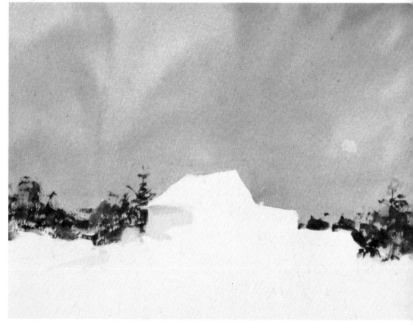

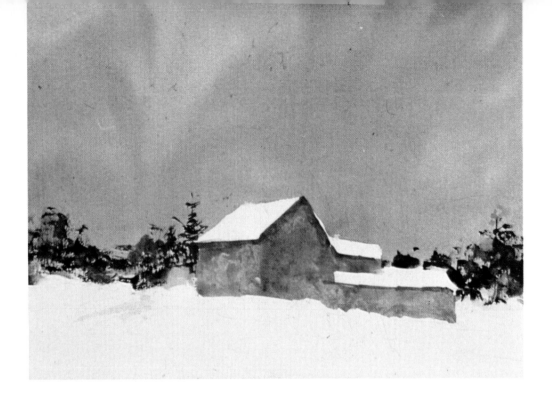

Step 4

Now I work on the building, fence and some of the wall, using yellow ochre, burnt umber and a touch of Payne's gray. The umber lowers the value of the building, while the Payne's gray relates the buildings to its surroundings. Repeating this sky color adds a harmony to the picture. I also use a little cerulean blue and burnt sienna. Notice that I continue to paint right over the main trees. Some students would draw the trees and try to paint *around* them—a process that could take forever.

Step 5 ↓

Now work on the large foreground trees is started. I can paint right over the sky, since it's easy to cover a light watercolor tone with a darker one. A #5 round sable is used for the trunk and larger branches and a #4 rigger for the smaller branches. Some alizarin crimson and cerulean blue add a hint of coolness to the mix. I want the "look" of the tree rather than the tree itself. Better a free, loose brushstroke than a tight, shaky line that exactly reproduces a particular branch.

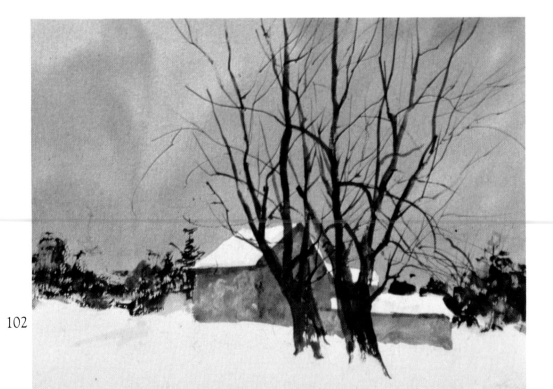

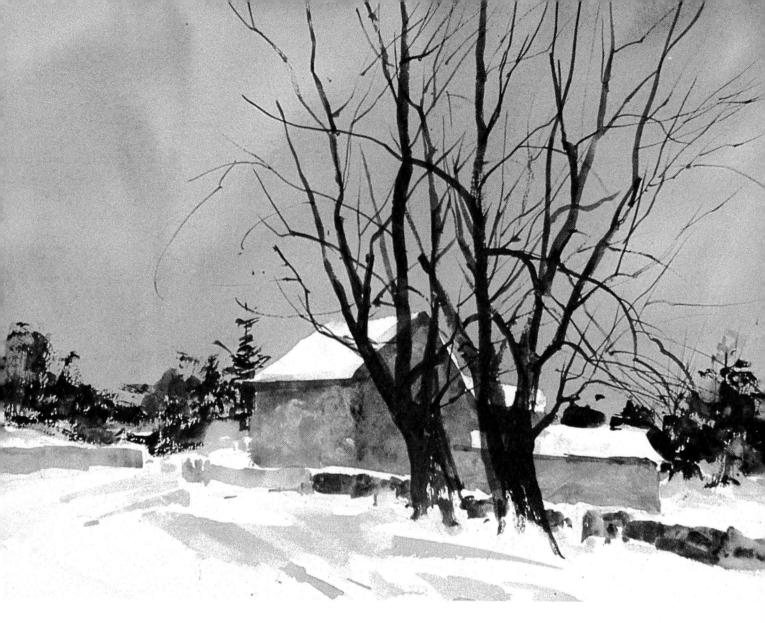

Step 6

Yellow ochre, cerulean blue, and burnt
sienna are used in the white fence and the
stone wall. Some of the colors of the sky also
reflect down onto the foreground snow. Hard,
soft and broken edges give movement to the
snow. At this point, the picture is established.
It "reads" from a distance and lacks only the
frosting of the "finishing touches."

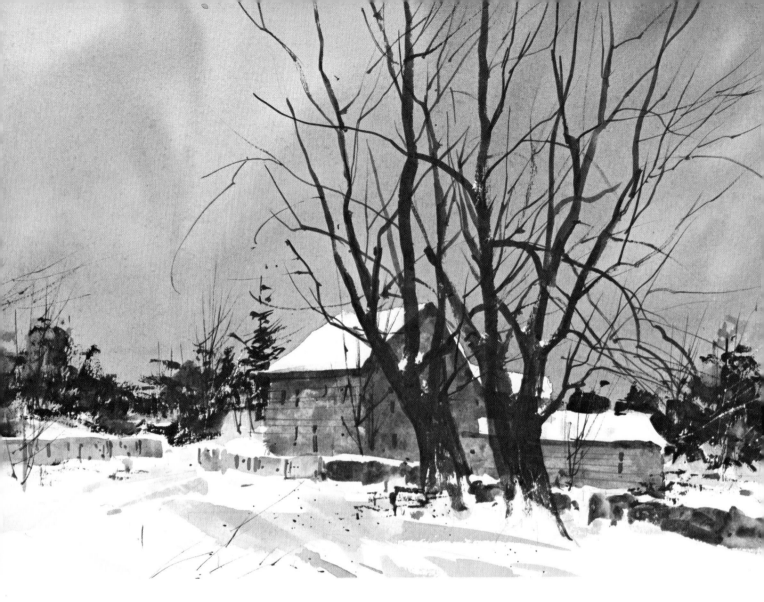

Step 7

Now I add some accents to the snow. Using the same familiar colors (alizarin crimson, Hooker's green, burnt umber, burnt sienna and cerulean blue), I spatter it on with a #5 round and draw fine grasses with my rigger. A few lines are added to suggest clapboards. Dry brush with burnt sienna under the tree is applied with the side of the rigger. This is done to only one of the trees so both trunks won't look alike. A razor blade works nicely to scrape out small branches and to suggest areas of snow in the branches of the main trees. I also scrape the trunks a little to suggest snow caught in the crevices of the bark. I'm down to the smallest brushes and am looking for things to add. When I decide that another stroke won't help, I'm finished. The picture probably needs more—but brushstrokes aren't going to help. And if I added more, I'd lose some of the excitement. How long does it take to do a picture? For me, the better ones take hardly any time. Or at least that's what I tell students to loosen them up. You'll have to answer the question for yourself.

7 Techniques

Now that we've studied the basic elements of painting—composition, values and color—and have seen how I paint a watercolor, let's take a brief look at the *least* important part of painting: technique.

Technique is a useful way to add extra visual interest to your work. But use your technique to paint a picture; don't paint a picture in order to use a particular technique.

When I started out, I was deeply interested in technique. I felt it was the real "magic" of painting. Nowadays I use few special methods. I'm not opposed to such things, but when you're outdoors you have to work quickly and directly. Usually you haven't time for a lot of experimental tricks. I use only the techniques that suggest the character of my subject. The subject tells me what to do.

Part of my reluctance to use too many gimmicks may also come from my training. I was taught to be a "purist"—and it's taken time for me to modify this attitude. Now I'm not afraid to use anything. The end result is what counts. At the same time I don't think students should study technique in hopes of finding "answers" to their problems. The more experienced you become the more you realize most problems can be solved by sticking to simple, old-fashioned principles and procedures.

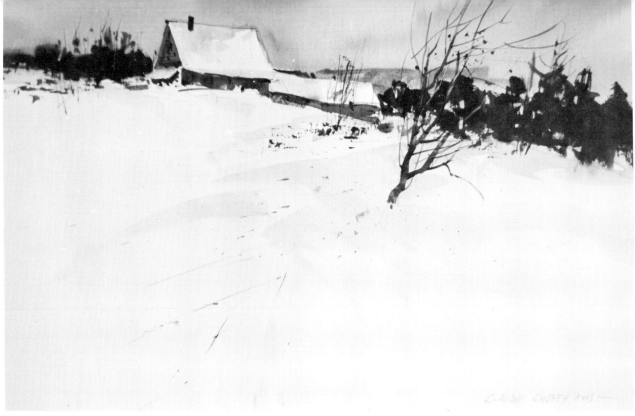

Figure 91

The Rigger and Wiping

Let's start with a few simple techniques. This winter scene (Figure 91) is based on an easily understood value pattern: light sky and snow, dark buildings and trees. Since everything is far from me the trunks of the trees and branches are very thin. They have to be kept thin in order to suggest distance. So I draw them with the point of my rigger brush. I also use the rigger *on its side* to suggest clumps or background grasses (Figure 92). To get the soft, wind-blown edges of the foreground snow, I first laid in a few light washes of color, moving from the paper's upper right to the lower left. While these washes were wet, I wiped across them—in the opposite direction—with a piece of tissue (Figure 93). The counter-movement softens the nearer edges. If these edges were left hard, the snow patches would have looked as if they had been cut out and pasted on the paper. You sense that the snow is moving up, down, and away from you. In addition, diagonal movements add excitement to an otherwise static composition.

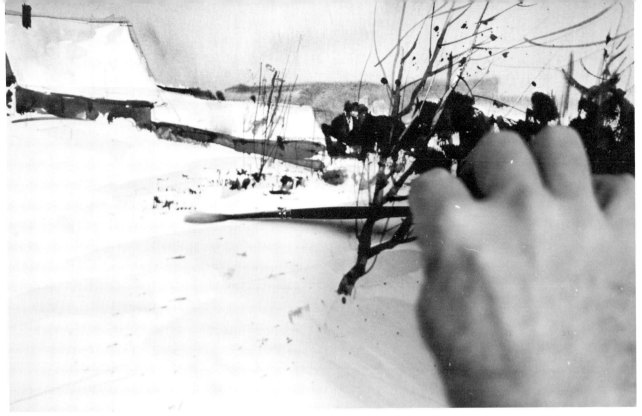

Figure 92

Figure 93

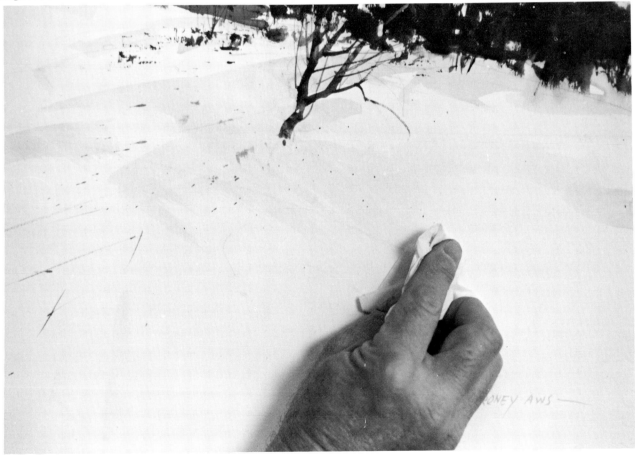

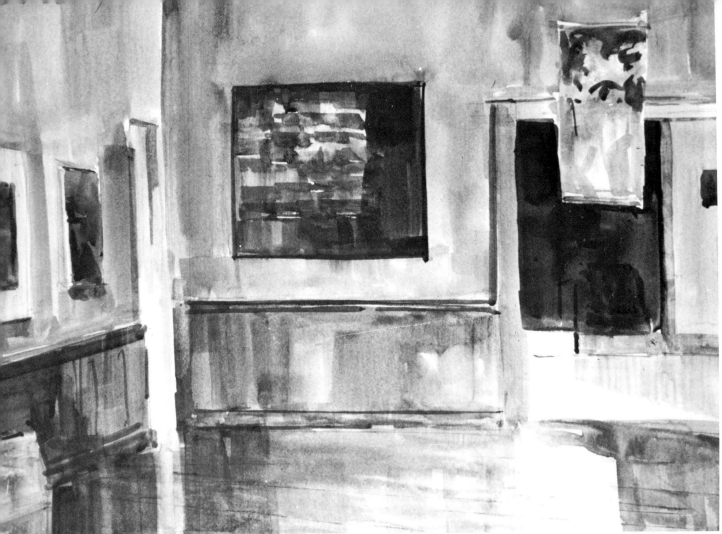

Figure 94

Flat Washes and the Knife

I painted Figure 94 in a gallery—in front of a workshop group. I wanted to prove you could find subject matter anywhere, once you learn to look for interesting shapes and values. This arrangement was especially abstract. I also liked the idea of looking from a darkened room towards an area lit by hidden windows. The emptiness of the place suggested the day I painted it: Easter Sunday. So that's what I titled the picture.

I decided that my one-inch flat brush was ideally suited for these square, angular shapes: it helped give the picture a solid look. I didn't let the strokes show everywhere, however—that would make the picture too lively and would contradict the sobriety of my subject. The walls are large, simple washes, with a suggestion of a flat stroke here and there (Figure 94). The flat

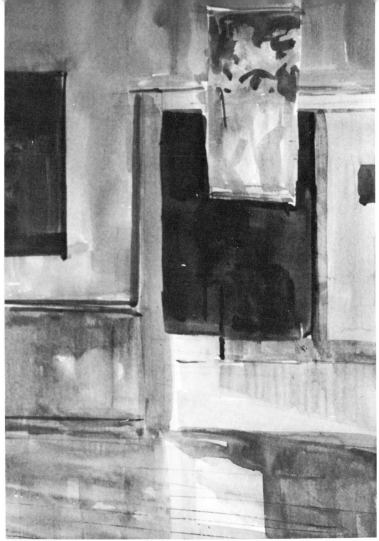

Figure 95

also helped me cut around the sharp edges of
the frames. I subordinated an area on the far
left of the painting by running the same flat
stroke over both the wall and a framed picture.
Color bled into the frame in the process. But I
didn't worry; I'd accomplished what I wanted.

Figure 95 suggests the important part dif-
ferent strokes play in even as simple and stark a
picture as this one. Look at the great variety of
edges, values and shapes in the lower corner.
Across this area I've used a painting knife to
add the straight, thin lines of the floor boards. I
first mix some paint on the palette and then
pick it up with the edge of the knife. When I
apply the paint, the knife actually creases the
paper. This crease holds the paint and creates a
razor-sharp line. At the same time, the paper
often takes the paint irregularly. The knife skips
and jumps, adding extra visual interest.

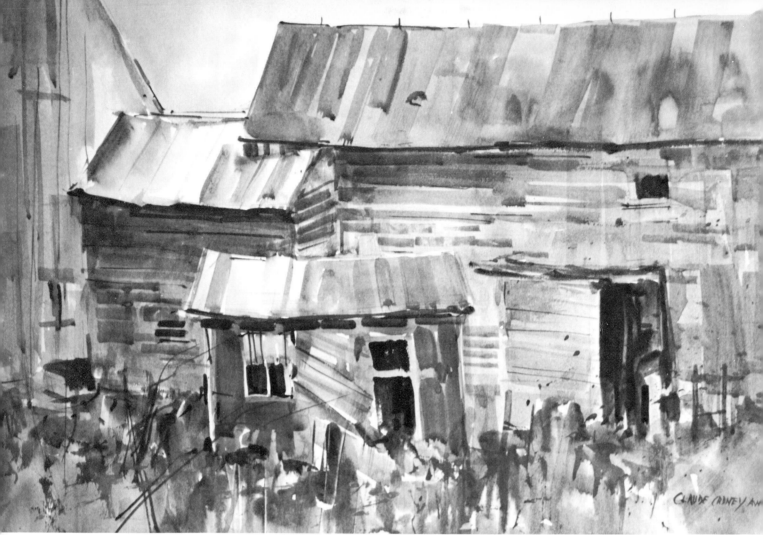

Figure 96

The Flat Brush: Tempo

At the site, the barn in Figure 96 was flatly-lit. Everything was close in value, and it was impossible to find a strong light and dark pattern. I decided to introduce a few areas of white paper—but where? The sky wasn't interesting enough to be white paper. So I used a few bits of it on the building itself; they give it sparkle. Cover these white areas with your hand, and you'll see how dull the picture is without them.

I again used a flat brush on the boards and slats. In contrast to Figure 94, I here made maximum use of the flat stroke—it suggests the broken texture of the boards. So the strokes wouldn't be too obtrusive, I kept their value close to those of the background washes. Notice that the tempo created by these staccato strokes is particularly lively towards the middle of the paper—near the center of interest. Many of these strokes are made by using only the tip of my flat brush (Figure 97). As I move towards the edges of the paper, the strokes become much less noticeable. On the far right (Figure 98), I subordinate an area and stop the eye by making a few long, flat, vertical strokes. They keep your attention inside the picture area.

Figure 97

Figure 98

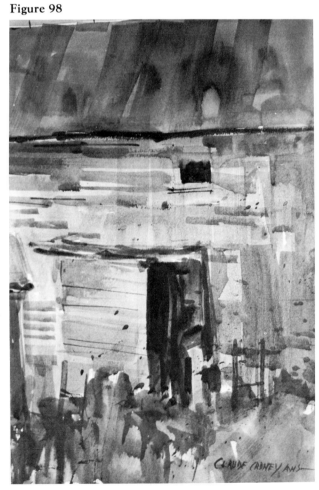

Since I don't want the dark doorway to float on the paper like an isolated black square, I use a few soft edges to integrate it into the surrounding wall. In a similar way, I blurred the top of the small window in the upper right. The blurred edge connects it to the wall.

Because the barn is painted with horizontal strokes, I use more vertical strokes in the land and grass. I relate the building and ground by keeping the grass and boards close in value. The two should not meet in a hard line. The barn should rest snugly *in* the grass—not sit starkly *on* it.

Figure 99

Wet-in-Wet and the Knife

I painted Figure 99 using a long, thin format—a format that suggests the broad line of the ocean. The picture is based largely on the contrast of hard and soft edges.

I began with the wet-in-wet sky, dampening the area near the burst of spray and then painting the sky into it. The resulting softness suggests the mist in the air. I similarly manipulated the horizon line and the edge along the top of the turning wave. These broken edges give a feeling of movement to the picture. There's always an element of chance when you paint such shifting edges. You have to watch what you're doing. If the edge looks too hard, add water to the surroundings. If it's too soft, blot and restate it.

I painted the dark foreground rock first (Figure 100) and then played the softer, distant rocks against it. I had to establish the dark rock, so I could decide how to handle my background values. It's hard to paint a light area

with only white paper as a guide. The foreground rock gave me a gauge. I used a palette knife to establish the sharp edges of the nearby rocks. Also the flat part of the knife was used to suggest their broken sides. I first brushed paint on, then squeegeed it around with the flat of the knife (Figure 101). That flattens some areas of color while breaking others into textured streaks. I then painted the right side of the picture (Figure 102) wet-in-wet. A few details were added. In doing this later, the rocks were dampened in order to keep the additions soft. The softness helps push the rock back.

The only real "details" in the painting are the dark rigger lines on the flat part of the nearest rocks. If these rocks were *more* detailed, I'd have been forced to do more work on the background rocks, too. Otherwise, it might look as if I'd only used the background area to wipe my brush! "Finish" is a relative matter. The viewer senses a continuity between the parts of a picture—he knows when each part fits. But he rebels if you have a photo-sharp foreground and a wildly abstract background.

Figure 100

Figure 101

Figure 102

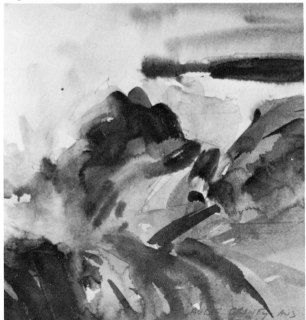

113

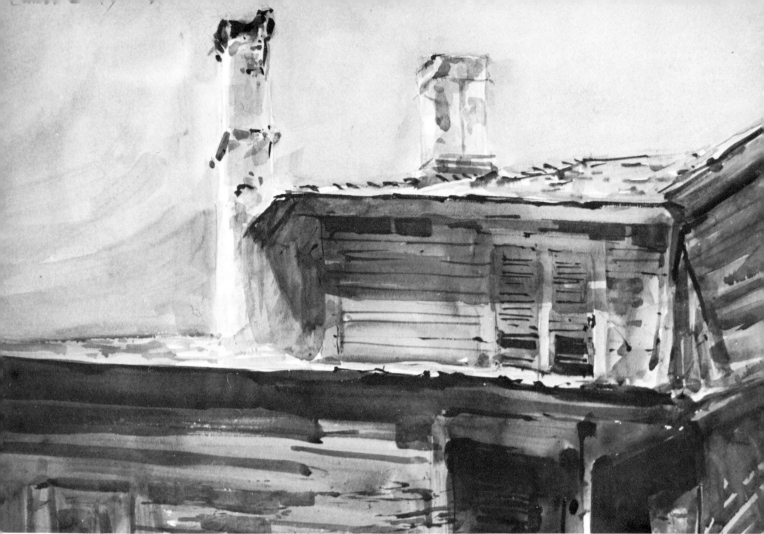

Figure 103

Blotting

When I arrived at the site of this painting (Figure 103), I liked the house—but there was just too much of it. I kept backing up against a clump of trees and couldn't get a good view of the place. Besides, I found I kept looking at the interesting roof and chimneys. So I knew that they were my subject.

When drawing the building, I made the architecture interesting by angling in on the paper. The eaves slant in different directions—none of them are straight. The chimneys also angle slightly. By bending and twisting everything, the character of the place is suggested. You know it's not a condominium.

The sky was actually the lightest part of the scene, but I decided it would be better to move the highlight *into* my subject. The sky was darkened slightly to show off the glare on the chimney and shingles. Notice, however, that both the sky and these highlights remain in the light family. The sky is still light, compared to the shadows under the eaves of the house. I've kept to the truth of nature, but altered it a bit to suit my purpose.

Using a big washbrush (Figure 105), I darkened the sky near the roof. That emphasizes the chimney. The character of these chimneys is suggested by just a few broken dots and lines. In addition, I used blotting to add visual interest. Sometimes I blot to lighten a spot that was accidentally made too dark. In this case, however, I purposely made the chimney spot dark

Figure 104

Figure 105

so I could blot it and give it extra texture
(Figure 104). The variety of value within this
blotted spot suggests reflected light, a change in
building materials—or almost anything!

Notice that as the architecture moves
towards the edges of the paper, it becomes less
and less textured. The important work is near
the center. That's where the shingles catch the
light, for example—they look like ripples on the
ocean. There are some interesting textures in
the lower right-hand corner. You can see part
of a trellis. A few bits of wood are suggested,
but most of the intersections were omitted.
They'd be boring to look at. This bit of texture
strengthens the corner and helps balance the
strong contrasts elsewhere in the painting.

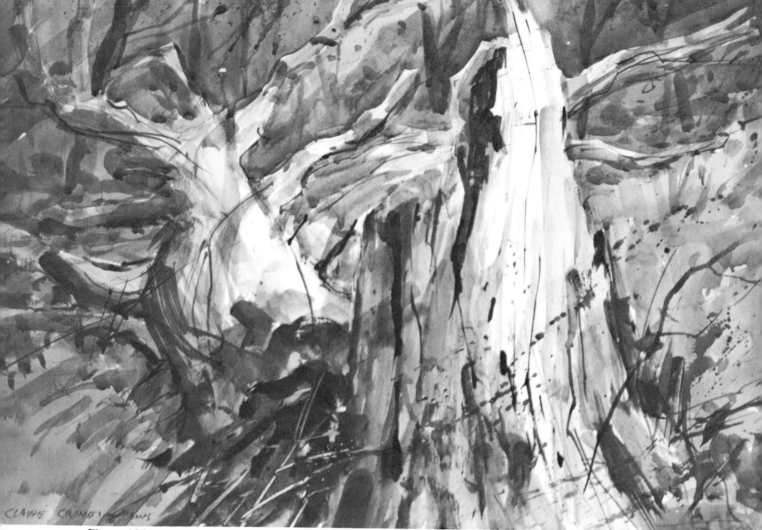

Figure 106

Dry Brush and Spatter

I painted Figure 106 on a farm in the far West. I could have shown more of the distant trees and sky, but I liked the stump and the action and movement of the dead branches—and so made them my subject. I extended some of the branches to emphasize this movement, pulling a few out of the top of the picture.

I painted the background first, leaving lots of white paper for the trunk and branches. It's easy to eliminate excess white paper—but hard to get it back again. Although the highlights on both the branches and the stump were equally bright, I finally decided to tone down the fallen tree and thus push it back in space. That made

the trunk the main actor. Here and there in the background (Figure 107), I glazed over areas to subordinate and unify them. On the far left, a stroke goes over both a tree and the area to either side of it. I didn't paint *up* to the tree; I painted right *over* it. I wanted to subdue the area—and this was the most direct way to do it.

I used dry brush texture on the branches and stump. You can see how the individual bristles of the brush suggest cracks in the wood. To make such a stroke, you have to use little water on the brush. How little is the problem. Wipe your brush and experiment. Experience will tell you when you have the right amount.

116

Figure 107

Figure 108

Figure 109

I used a twisting and turning line to add a gnarled look to the trees (Figure 108). I adjust the value of these lines; they're lighter in the background and darker in the foreground. I also made a few light lines by scratching into the wet paint with my fingernail (Figure 109). These lines emphasize the slope of the land and counterpoint the opposing movement of the fallen tree. Such diagonals add excitement to the picture. Although I'm painting a dead tree, the picture is still lively to look at.

Spatter is used in both the foreground and the background. You spatter an area by getting a fair amount of paint and water on the brush, pointing it in the direction you want the spatter to go, and then hitting the brush against the side of your hand (Figure 111). Do this gently at first. Some students knock the brush against their hand and send spatter all over the paper, their shoes, and their eyeglasses. Experiment until you sense how the paint behaves. In the foreground, the spatter suggests holes in the wood. The spatter goes beyond the trunk and onto the distant grass. That's OK: out in the field it could represent grass or rocks. I also break up a nearby dark by using some opaque

Figure 110

Figure 111

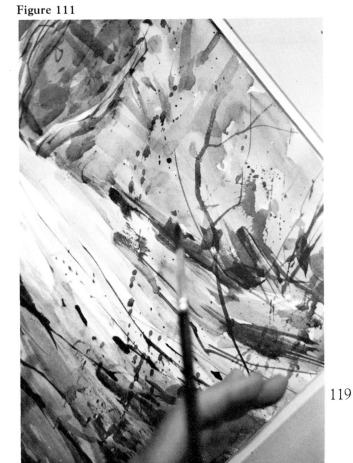

spatter to the left of the dead trunk. In the background (Figure 110) the spatter suggests foliage. It gives the area a broken look—a look that reflects the way things are naturally.

I had one unforeseen technical problem with this picture: my paint ran while I was washing in the background. You can see the remains of a drip towards the center of the fallen tree. I blotted the spot with a tissue—and kept on painting. You can't stop in watercolor. And you can't panic. As it turned out, I later decided to glaze the background tree and the stain was no longer noticeable.

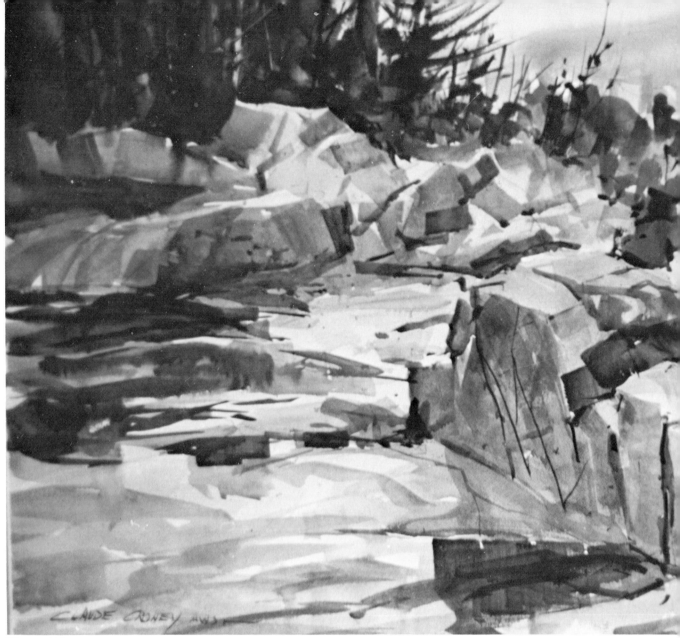

Figure 112

Flat Brush: Angular Structure

In Figure 112, I liked the way reflected light kept the shadowed rocks from being too dark in value. In order to better judge how light to make these rocks, I painted the dark background trees first. I twisted and turned a round brush to suggest trees and masses of foliage. Although I varied the values within the mass, I kept the trees simple. Too much detail would detract from the rocks. I used some line and dry brush strokes for branches and foliage. I also scraped out a few trunks and branches with my fingernail.

120

Figure 113

The rocks were hard to paint, since I had to create the feeling of solidity—without strong value contrasts. The rocks, both light and dark, read as a single unit.

The flat brush is perfect for the painting of these angular rocks. In Figure 113, you can see how I use the brush strokes to follow the structural planes. Of course, you can overuse the flat—just as you can overuse any tool. The stroke then becomes monotonous. I don't try to "make" rocks with the brush; I simply use it to suggest their forms.

121

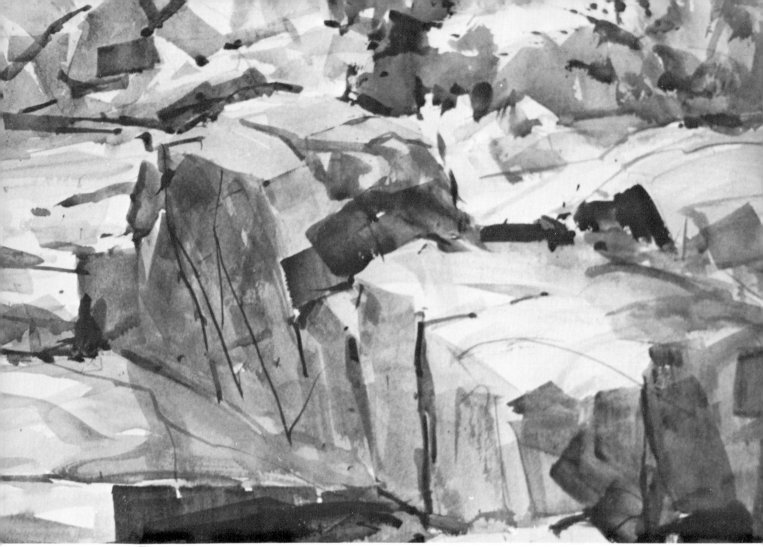

Figure 114

The rocks were started with large light washes. I then painted into them once they dried. I leave lots of white paper at first and cut down on it as I proceed. Towards the end of this picture, I could see that the less white paper, the more effective the sparkle would be. So I kept only a few key bits and pieces.

Throughout the picture, I try to contrast big strokes, small strokes, and sharp accents. I again blur my edges towards the borders of the paper. This is especially evident on the far left. A lot of these edges are lucky accidents; they just happen. But I had to know when to keep them and when to wipe them out.

When I painted the rocks, I tried to suggest their shapes rather than copy them. If I see a good shape, I use it. But I don't fight with the subject, struggling to get it "right." I also change my mind while I paint. In the upper

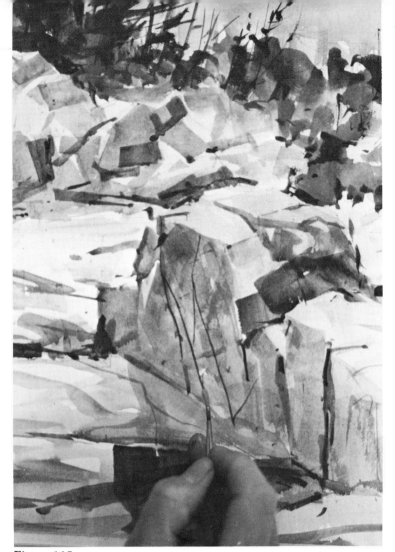

Figure 115

part of Figure 114, for example, you can see how some of my original pencil marks contradict the final washes. Sometimes I see things that look better than what had been planned. So I use them.

There are very few lines in this picture. At the end of the painting process, I add some— just to point things up. You can find a few in the foreground rocks (Figure 115). If you squint, however, you no longer see them. The "English Method" of watercolor uses lots of light washes and then ties the picture together with line. The line explains the color masses. I work in just the opposite way. My masses tell the story, and line is merely a seasoning—I don't need a lot of it. Students often hope lines can save a weak value pattern. But such lines rarely work. In watercolor, less is usually more—and best.

8 Advice

The student's job is to decide how much of a teacher's ideas he can use. When I was a kid in Cambridge, I modeled for the local artists. I heard the instructors talk about the importance of checking the position of a figure's shoulders and legs. I picked things up. Then I checked to see if they made sense to me. I didn't worry about whether they were right or wrong; I just wanted to know if I could *use* them.

It's easy to get into a rut. You want to learn, but you don't want to change. I don't have all the answers. You're the artist. You have to make the final decisions. In the end, all teaching comes from the student himself. Others can give you hints that will take you maybe 20 percent of the way, but you have to dig 80 percent out of yourself. The good part is, once you've discovered something on your own, it's yours forever.

So don't accept everything I say. Get the important ideas and forget the details. Don't try to paint like me. Paint like yourself. Students forget to be themselves. They attempt to be one instructor one week; another, the next. They end up copying everybody. Don't be so humble! I was lucky, for even when I was in high school I knew that I was myself—and the teacher, himself. I never got the two mixed up. You'll work better if you relax and understand that, as Frank Dumond said, teacher and student are both lost in the woods. Only the teacher's been there longer and can show you part of the way out.

Confidence

The last thing to worry about is whether you can do a thing or not. If you're unsure what will happen when you make a stroke, that's all the more reason to make it. The more problems you have, the more you learn. And you only learn by doing what you don't think you can do. Remember: you can destroy and mutilate a piece of watercolor paper, but you never waste it! You're not defeated when you go down—you're defeated when you stay down...when you give up.

To build confidence, it helps to do quick paintings. Set a time limit of 15 or 20 minutes. These pictures don't have to be good. But they should make you work and think quickly. Forced to *say* something, you get away from picking and poking. The exercise shocks you and lets you have some fun. Of course, you won't want to paint fast all the time, but the practice will give your pictures an added directness and authority. The viewer sees that you're not timid or scared. You know what you want to do. You let it happen.

Shows

You can also build confidence by studying the work of other painters. I was once afraid of going to shows; I thought I'd be "influenced." You have to know how to learn from an exhibition. Ask yourself questions: why, for example, does a picture look well in a show? Is it because of its variety of shapes? Its values? Its color? Why did you look at the picture in the first place? Don't study technique; instead, look to see what the painter is trying to tell you about shapes and light.

Exhibit your work, too. You have to show it eventually, and getting into shows is a good way to learn. Join art clubs and associations. Belonging to organizations makes you work. And when you see your pictures hanging with others, it keeps you honest. You're nailed naked on the wall. With nowhere to hide you learn to accept yourself.

At home, your work probably looks pretty good. When it's in a large hall, surrounded by other paintings, you can look at it more objectively. You not only see aesthetic problems—whether the picture is too light, too dark, or well or ill-drawn—but you also note practical problems. Maybe a nearby picture has a better mat, or perhaps your framing doesn't come up to professional standards.

How do you choose a picture for a show? Pick a few favorites and run your eyes over them. Look for distracting movements and shapes. Put five or six against a wall and look at them from fifteen feet away. See them as they'd appear at an exhibit. Leave the room; then come back and look at them with a fresh eye. Why do some seem to work better than others? What do the others lack? You may not know the answers—but at least you're asking the right questions.

Style

"Well," somebody said to me at a party, "I hear they're doing a lot of hard-edge work this year." Personally, I don't care if hard-edge or

soft-edge is the rage—such talk gives me a headache! People who can't find themselves make a career out of following the latest trends. It's easy to be accepted if you work in a popular manner. But I just want to paint better—in my own way. Forget about style. Style comes of its own accord. Sink your teeth and nails into what you're doing, and you'll make your own theories and style. You'll paint like yourself because you can't do it any other way. It's like handwriting. I see a neat hand and think I'd like to write that way. Then I sit down, and out comes my usual scribble. I decided long ago that I'd rather be a poor me than a good imitation of somebody else!

How you paint is a matter of personality. I like a quick, spontaneous approach, but that doesn't mean I hate tight work. I'd rather use four strokes than forty, but I'll put in sixty if the picture needs it. I get excited by a scene and I don't believe in sneaking up on it. I like work that has a candid look—as if the painter trapped a moment of time.

A lot of my feeling is the result of the way I've lived my life. My early pictures were dark and somber. They reflected a time when I was just starting out. I was uneasy, introverted and unsure of myself. I wanted to paint but couldn't. I had to earn a living. With the passing years I've become more confident in my work. I'm happier, and my paintings have increased both in color and boldness.

I also feel that loose, elusive work gives the viewer a chance to finish the picture to fit his own mood. He becomes *part* of the painting, and sees something different in it, everytime he looks at it. A picture painted by rules and a T-square is usually the same. It's like a photograph. It never grows, breathes or changes—it never looks any better.

Between abstraction and photographic realism, there's plenty of room for experimentation. I like to see something of both: abstract design and realistic subject matter. Getting both is much harder than doing just one or the other. There is liberty within restrictions. That's part of the challenge. Make the best of both worlds. That, to me, is what painting is all about.

Personal Growth

In art, you grow in steps. You reach a plateau and level off. Then, just as you begin to think you've reached your full potential, you suddenly jump ahead. Physical growth stops at a certain age. In art, you have to keep reaching—then you can grow forever.

The aim of all painters is the same: to paint better pictures. After years of studying values and looking for compositional patterns, I now find myself becoming more and more interested in drawing. I want to be more disciplined in my drawing—though I'm painting more and more "loosely." I want a kind of drawing that's less tied to subject matter. I don't want to copy a subject; I want to *create* it. I want to put more of myself into it.

That's why I never keep examples of my own work for a "private collection." That would create a standard, and that standard might put brakes on my future growth. I've got a lot more work to do. And my best pictures are ahead. The next ones: those are the important paintings!